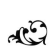 The Theatrical Baroque

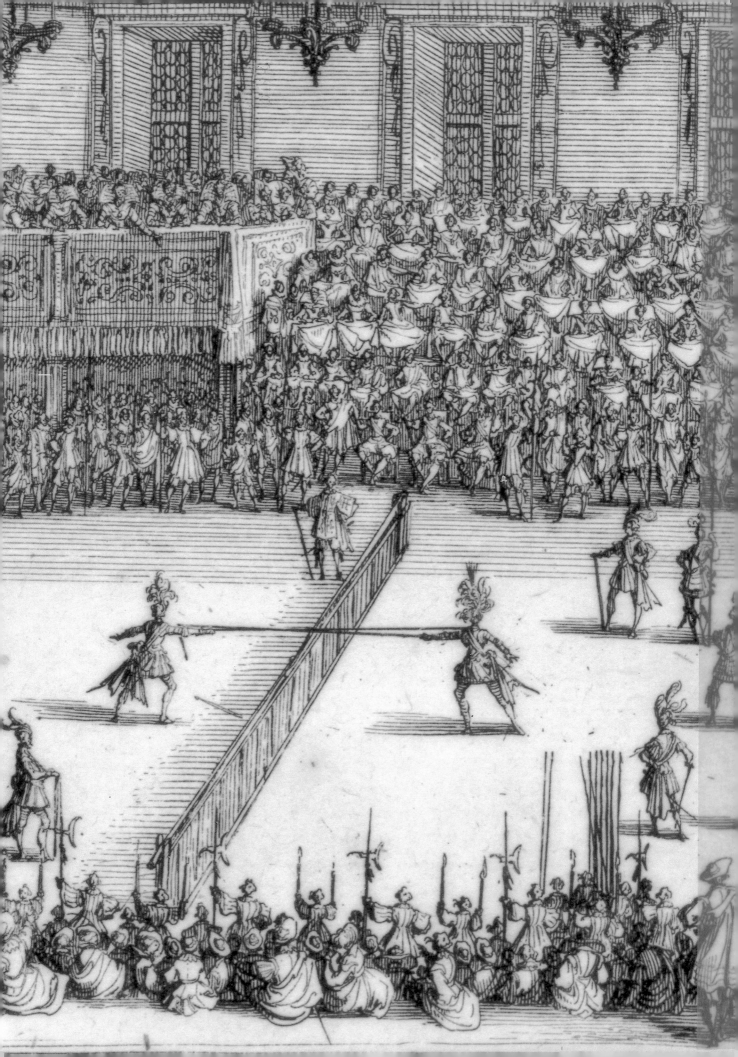

The THEATRICAL BAROQUE

Larry F. Norman

WITH CONTRIBUTIONS BY
Josh Ellenbogen, Brandy Flack, Rebekah Flohr, Anita M. Hagerman-Young,
Robert S. Huddleston, Matt Hunter, Véronique Sigu, Kerry Wilks,
and Delphine Zurfluh

THE DAVID *AND* ALFRED
SMART MUSEUM *OF* ART

THE UNIVERSITY OF CHICAGO

Catalogue of an exhibition at
The David and Alfred Smart Museum of Art
The University of Chicago
9 January–22 April 2001

This catalogue was funded by a multiple-year grant from the Andrew W. Mellon Foundation to the Smart Museum to encourage interdisciplinary use of its collections by University of Chicago faculty and students both in courses and through the format of special exhibitions.

Design and typesetting: Joan Sommers Design, Chicago
Production and Copy Editor: Elizabeth Rodini
Copy Editor: Britt Salvesen
Printed in Hong Kong by C & C Offset Printing Co., Ltd.

Cover: Noël Hallé, *Joseph Accused by Potiphar's Wife*, 1974.116 (Cat. No. 19)
Reverse Cover: Jacques Callot, *Entry of His Highness as the Sun*, 2000.16h (Cat. No. 2)

Photography Credits: Photography by Tom Van Eynde unless otherwise noted; figs. 13, 14, 29, and 31, Smart Museum Archives; fig. 4, photograph © Board of Trustees, National Gallery of Art, Washington; figs. 5 and 12, photographs courtesy of The Art Institute of Chicago; figs. 6, 10, 25, and 32, photography by Ted Lacey, Department of Special Collections, the University of Chicago Library; fig. 8, New York, Alinari/Art Resource; fig. 34, The Newberry Library, Chicago.

Library of Congress Catalog Card Number: 00-133461

ISBN: 0-935573-29-1

Contents

The Theatrical Baroque is the result of collaboration between the Smart Museum of Art and Professor Larry F. Norman of the Department of Romance Languages and Literatures, who worked with museum staff and collections to define and shape the project. Its aim is to explore some of the many intersections between theater and the visual arts in seventeenth- and early eighteenth-century Europe, both in formal and conceptual terms. The exhibition and catalogue investigate how the more familiar devices of the period—grand scenography and dramatic gestures, for example—illuminate critical debates in baroque culture, including those concerning the proper role of art, the relationship of reality to representation, and the nature of social hierarchies. In a period characterized by rapidly shifting understandings of the world and the universe, growing uncertainties about the proper order of things, both natural and social, fueled these debates. One result was an intense interest in the power of illusion, as the arts of both stage and canvas explored the boundaries between the actual world and the imagination. As Professor Norman explains in his introductory essay, we have cast our net broadly in terms of what is considered "baroque." For the purposes of this project, we have chosen to define the era as extending into the middle of the eighteenth century, when the novel began to overtake the play as the decisive popular literary genre.

This exhibition and catalogue are part of an ongoing series of projects sponsored by the Andrew W. Mellon Foundation to encourage creative rethinking and reinstallations of the Smart Museum's collections by University of Chicago faculty and students. *The Theatrical Baroque* began as a graduate student seminar taught in the spring of 1999 by Professor Norman. The themes covered in the course provided the starting point for the essays included here, in which student authors consider works in the Smart's collection within the context of larger issues that shaped baroque society. The participation of these nine authors is a critical element of the Smart's Mellon projects, which seek to involve students and faculty directly with museum objects, to expose them to the workings of a museum and the demands of crafting an exhibition, and to give students an opportunity for concentrated research and publication. The interdisciplinary nature of this project—which involved students from four different academic departments—is particularly satisfying, and reveals the unique resources and possibilities open to a university art museum.

We are indebted to the many people who made this exhibition and catalogue possible. Larry Norman has been an enthusiastic, energetic collaborator who has

brought fresh ideas and insights to the museum. His graduate students have shared his spirit and drive. We thank all the members of his seminar, and particularly those whose essays are published here. The visiting scholars invited to campus by Professor Norman—and thanked more fully in his acknowledgments—enriched the seminar by offering in-class presentations, public lectures, and individual advising to students. Their participation and the intellectual depth it offered were central to the development of this project.

Our thanks also go to the lenders who have generously contributed works to this exhibition. These include two anonymous lenders; the Department of Special Collections at the University of Chicago's Joseph Regenstein Library, particularly Exhibitions and Conservation Supervisor Valarie Brocato and Curator Alice D. Schreyer; the Newberry Library, including Project Assistant Susan Summerfield Duke and Associate Librarian Mary Wyly; the Department of Prints and Drawings at The Art Institute of Chicago, especially Laura M. Giles, Research Curator of Italian Drawings, and Suzanne Folds McCullagh, Curator of Earlier Prints and Drawings; the Department of European Painting at The Art Institute of Chicago and Larry J. Feinberg, Patrick G. and Shirley W. Ryan Curator; and the National Gallery of Art, Washington, D.C., including D. Dodge Thompson, Chief of Exhibitions, and Earl A. Powell III, Director. Many members of the Smart Museum staff contributed to the success of this project, including Mellon museum interns Christine L. Roch, Stefania Rosenstein, and Simone Tai; Preparator Rudy Bernal; Preparation Assistant Tim Duncan; Registrar Jennifer Widman; and Senior Curator Richard A. Born.

Finally, we thank Angelica Zander Rudenstine, Senior Advisor for Museums and Conservation at the Andrew W. Mellon Foundation, for her ongoing support and assistance with this and other Mellon-sponsored projects, and Elizabeth Rodini, our Coordinating Curator for Mellon Projects, who guided this project to fruition with her usual intelligence, skill, and perseverance.

KIMERLY RORSCHACH
Dana Feitler Director
Smart Museum of Art

Acknowledgments

This exhibition and catalogue owe their existence to Kimerly Rorschach's bold and happily unorthodox decision as the Smart Museum's Director to enlist non–art historians in the curatorial process. Her leadership and support, as well as that of Senior Curator Richard A. Born, have turned the generosity of the Mellon Foundation grant into a vital opportunity for interdisciplinary investigation at the university and the museum, bringing a wide gamut of literary and theater scholars together with art historians.

Among the distinguished scholars who participated in the seminar that shaped this exhibition, I would like to thank Patrick Dandrey, Université de Paris-IV, La Sorbonne (whose visit was co-sponsored by the Chicago Group on Modern France); Nicholas Hammond, Cambridge University, Gonville and Caius College; Bruce Redford, Boston University; and University of Chicago Professors Ingrid Rowland and David Bevington. The exhibition reflects as well the diverse intellectual contributions of a talented group of graduate researchers in the seminar, in particular the contributors to this catalogue: Josh Ellenbogen, Brandy Flack, Rebekah Flohr, Anita M. Hagerman-Young, Matt Hunter, Véronique Sigu, Kerry Wilks, and Delphine Zurfluh. I am particularly grateful to one contributor, Robert S. Huddleston, who as the seminar's course assistant also helped form the original contours of our investigation.

Among the many institutions whose generosity Kimerly Rorschach has mentioned in her foreword, I would like particularly to thank the Department of Special Collections at the University of Chicago, which is running a simultaneous and collaborative exhibition, *The Book in the Age of Theater*. Reader Services Librarian Jay Satterfield assisted with the selection of books for research and study, and Curator Alice D. Schreyer shared with the class her knowledge of baroque printed plays and book engravings.

Finally, I would like to thank one person whose intelligence, hard work, and dedication has truly made this exhibition and catalogue take concrete shape. Elizabeth Rodini, as both coordinating curator and production editor, has almost single-handedly turned the chaotic findings and musings of a graduate seminar into a coherent catalogue and splendid show. Her name is not on the front of this volume, but, as much as any other contributor, she deserves credit for this collective effort.

LARRY F. NORMAN
The University of Chicago

Plate 1
Noël Hallé
Joseph Accused by Potiphar's Wife,
circa 1740–1744
(Cat. No. 19)

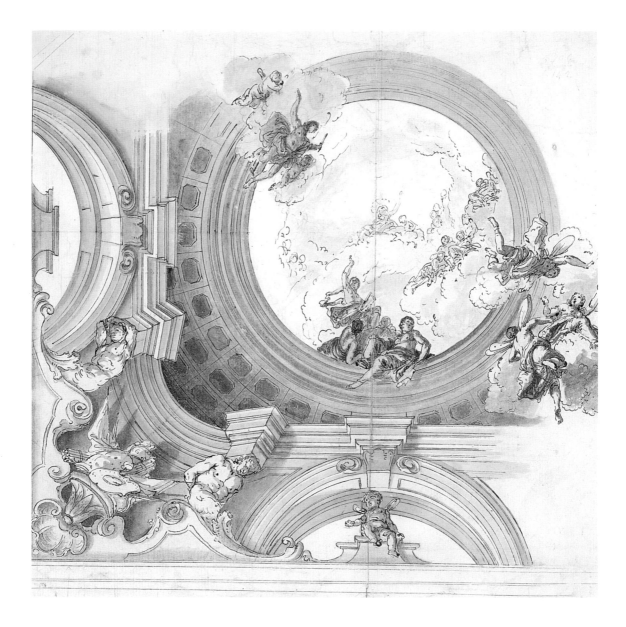

Plate 2
Daniel Gran
Design for a Ceiling,
circa 1720–1757
(Cat. No. 27)

Plate 3
Carlo Innocenzo Carlone
Study for *Parnassus Triumphant*,
circa 1720–1730
(Cat. No. 25)

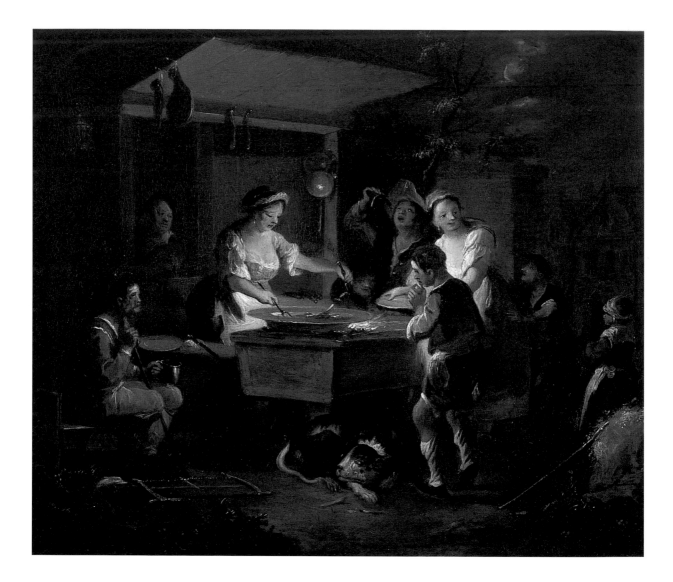

Plate 4
Franz Anton Maulbertsch
The Sausage Woman,
circa 1785–1790
(Cat. No. 6)

Plate 5
French, Chantilly Factory
Shell-form Bowl with Platter,
circa 1750
(Cat. No. 17)

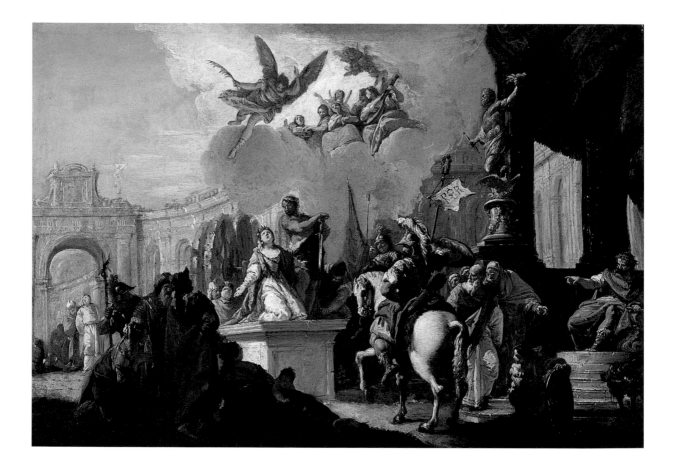

Plate 6
Francesco Fontebasso
The Martyrdom of Saint Catherine,
1744
(Cat. No. 23)

Plate 7
Artist Unknown, French
Allegory of Truth, Honor,
Prudence, Vice, and Posterity,
circa 1745–1775
(Cat. No. 31)

Plate 8
Francesco Montelatici,
called Cecco Bravo
Angelica and Ruggiero,
circa 1640–1645
(Cat. No. 11)

 The Theatrical Baroque

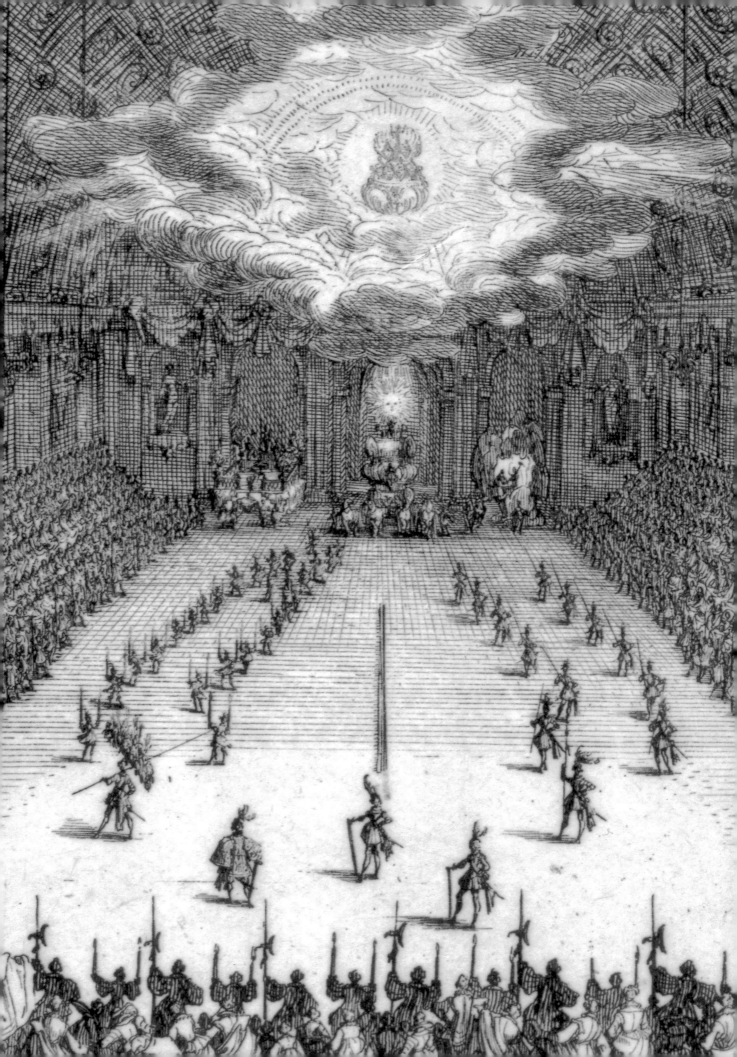

THE THEATRICAL BAROQUE

LARRY F. NORMAN

All great diversions are dangerous for a christian life, but among all
those the world has invented none is to be so feared as that given by
theater: it creates a representation so natural and so subtle of human
passions that it excites and engenders them in our heart.
— PASCAL, *Pensées*, 1655–62[1]

OF ALL THE BRILLIANT SPLENDORS and alluring vices of baroque France,
why would the stern philosopher Pascal dub theater the most dangerous of
all social or artistic seductions? The answer is simple: though the period is
known for its wildly opulent court festivities, its mania for gambling, and the worldly
"gallantry" (as it was then decorously called) of its salons, none of these diversions
exercised so forceful a hold on the public as did theater. As Pascal's remark makes
clear, the stage captivated audiences with what seemed a perfect reflection of life, an
image of human emotions "so natural and so subtle" that it could equal, and even
best, the real thing. By the mid-seventeenth century, the theater had allied art and
technology to create a medium that vanquished all competitors. Corneille had molded
French verse into a perfect dramatic instrument, one that Molière and Racine would
soon perfect in their own styles, leaving epic and lyrical poetry well behind in prestige
and popular favor. Great advances in stage machinery and design were ushering in a
whole new genre of special-effects plays that recreated mythological marvels, mira-
cles, and cosmological journeys before captivated audiences. The physical energy,
bodily heat, and even sweat and spit of celebrated performers were palpably close to
spectators, especially those lucky and wealthy enough to be seated on chairs placed on
the stage next to the actors. And thanks largely to some imported talent from Italy,
France would soon be experiencing the enchantment of intertwining music and verse
as the new form of the opera spread north.

Moreover, as this transalpine influence suggests, there was nothing geographically
exceptional about the triumph of theater in France, despite timeless French claims to
cultural singularity. Theater obsessed the cultural imagination of Western Europe
from the second half of the sixteenth century, when the first permanent theater buil-
dings since antiquity were constructed in Italy; through the Spanish Golden Age; the
French classical age; and the English Elizabethan, Jacobean, and Restoration peri-
ods—in fact through the mid-eighteenth century, when the rise of the novel left the
playhouse in an increasingly secondary position in cultural importance. The period art
historians call the baroque was the age of theater. And just as diverse national tradi-

tions contributed to this outpouring, so too did various dramatic and poetic genres compete, collide, and couple in an explosion of forms. Theater was universal in its ambitions. It represented humanity in historical grandeur, rustic simplicity, urban realism; it depicted gods, saints, and peasants, past kings and present fools. This embarrassment of riches is most famously catalogued (and lampooned) in *Hamlet*, when the verbose Polonius details the traveling troupe's repertoire: "The best actors in the world, either for tragedy, comedy, history, pastoral, pastoral-comic, historical-pastoral, tragical-historical, tragical-comical-historical-pastoral, scene individable, or poem unlimited."

These last arcane terms, "scene individable, or poem unlimited," it should be added, signal one last sign of theater's cultural dominance: its hold on the attention of intellectuals and theorists, who spent an enormous amount of energy crafting a learned terminology and a set of abstract principles for the stage. In this case, "scene individable, or poem unlimited" refers to a much debated, and often ignored, rule requiring one single unchanged setting for the entire play, a rule justified by the famous "unities" of place, time, and action. These and other elaborate principles were culled, often with great interpolative imagination, from Aristotle's *Poetics* by late sixteenth-century Italian theoreticians; for the next two centuries, they provided fodder for innumerable theoretical prefaces and treatises by playwrights such as Lope de Vega, Corneille, Molière, Jonson, and Dryden, as well as for a host of professional theoreticians and critics.

All of this creative activity and theorizing transformed theater into an intellectual and imaginative model for understanding the world in all its aspects. The ancient formula *theatrum mundi*, the world is a stage, became the motto for the age. Acting and sets, scripts and plot construction were metaphors applicable to every domain of human action: the science of politics, the metaphysics of the universe, the morality of private life—and even the art of painting and sculpting. It is this last aspect that interests us here, and the essays in this catalogue explore the most important elements of the dialogue between theater and the visual arts: the relation between dramatic unity and the concentrated storytelling of the canvas, between the actor's art and the rhetoric of gesture in painting and sculpture, between stage design and pictorial construction, and between the role of the theater spectator and that of the artwork's beholder, to name just a few. But before looking at the power of theater to shape both artistic creation and art criticism, I want to consider this simple question: Why *then*? Why did theater exert such a powerful influence over its sister arts in this period stretching from the late Renaissance through the early Enlightenment?

One impetus for the rise of theater came from a most unlikely source: the Church. After the Council of Trent (1545–63), the Church launched its powerful propaganda campaign against the Reformation, using all the means of persuasion at its disposal: opulent architecture and decor, eloquent sermon oratory, powerful painting and sculpture. Despite its continuing distrust of the immorality of theater (actors were, for example, excommunicated), the Church could not easily afford to disdain the persuasive powers of the stage. For the same reasons Pascal denounced theater— its capacity to stir the emotions of its spectators with a lifelike replica of human existence—the Jesuits embraced theater as a pedagogical tool. Through a humanistic marriage of the heroic, secular virtues of antiquity and Christian morality, they created

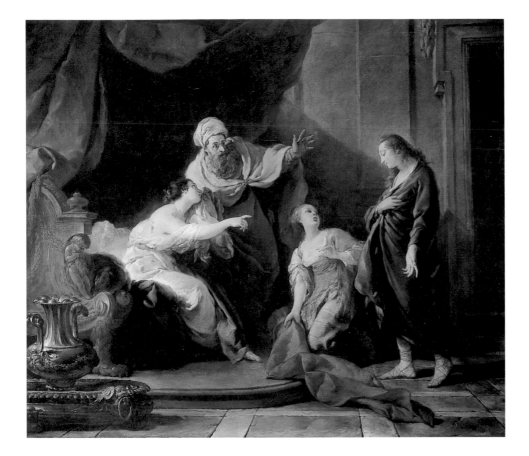

Figure 1
Noël Hallé, *Joseph Accused by
Potiphar's Wife,* circa 1740–1744
(Cat. No. 19)
See Color Plate 1

images both appealing to a larger public in their human drama and edifying in their intended effect. Dramatic reenactment could, through the power of declamation, gesture, and set machinery, put into living motion the kind of exalted religious images prized in painting and sculpture, exemplified here by Francesco Fontebasso's eighteenth-century representation of the martyrdom of Saint Catherine [COLOR PLATE 6]. The resulting religious drama was most fully institutionalized in Spain, reaching its artistic summit between 1648 and 1681 with the *autos sacramentales* of Calderón. Nevertheless, this Counter-Reformation embrace of theater could not everywhere entirely surmount the antagonism between pious devotion and worldly entertainment so powerfully suggested by Pascal. In France, the Jesuit playwright Corneille among others dramatized saints' lives, but these works were highly controversial for their representation of the "mysteries" of Christian faith, felt by many better left to the pulpit alone. Stories from the Old Testament, however, allowed religious passions and edification to enter the stage without the problematic depiction of Christian material. Racine distilled this form of drama to its purest state with his adaptations of *Esther* and *Athalie*, condensing the biblical accounts into their barest and most potent theatrical elements. The influence of this kind of theatrical crystallization of emotional impact can be seen in Noël Hallé's *Joseph Accused by Potiphar's Wife* [FIGURE 1/COLOR PLATE 1], a painting to which I will return.

No doubt even more important than the Church in promoting the rise of theater was the political power of princely courts. As feudalism and its attendant dispersion

of power died away, new centralized courts sought to increase their sway over the public's imagination with propaganda campaigns that equaled that of the Counter-Reformation Church. And again, nothing advertised their magnificence so well as dramatic spectacles. Presented both outside and indoors, in splendid gardens or palatial halls, court festivities allied the theatrical elements of costumes, sets and stage machinery, and mythological stories with the traditions of jousting games, processions, and court balls. The resulting productions not only stunned the original spectators, but were often further publicized through engravings and festival books that illustrated the proceedings. A superb example of this kind of publicizing activity is to be found in the Smart Museum's series of prints by Jacques Callot. These engravings were created as illustrations for *The Combat at the Barrier*, an account, in prose and poetry, of the opulent festivities staged by the Duke of Lorraine in 1627 in celebration of the visit of the politically potent Duchess of Chevreuse.² All the elements of baroque splendor were employed in this extravagant production: in one engraving alone [REVERSE COVER] we find floating fountains, gardens, grottoes, and orchestras—all propelled as if by magic by men hidden under the carts—as well as human figures metamorphosed into fruit-bearing trees, and, in a triumphant pose, the fabulously costumed duke himself as Apollo. The procession of floats and players toured the grand hall of the palace while saluting the hundreds of spectators in the six tiers of seating [FIGURES 2 AND 3]. The spectacle was occasionally spiced with some theatrical special effects, such as a simulation of exploding heavens and descending planets. This was followed by the chivalric games, which provided a gratifying opportunity for the noble participants/actors to exchange their roles of mythological gods for those of the gallant heroes of Renaissance and baroque romances.

The extravaganza staged in the Duchy of Lorraine gives just a glimpse of the kind of elaborate spectacles produced in the baroque age by the even richer national courts of Europe. In Stuart England, the court masque was chosen as the perfect expression of the splendor and ambition of the monarchy under James I and Charles I: playwright Ben Jonson and architect Inigo Jones collaborated to create masque mixtures of drama and pure showmanship that dazzled their original spectators with the sumptuousness of the decors, the inventiveness of stage effects and machinery, and the beauty of song, verse, and dance. It was of course at Versailles that absolute monarchy created its most spectacular and theatrical expression of power. The formal gardens of André Le Nôtre were not only a figurative stage for the court life acted out before the backdrop of the palace; they were also literally the site of some of the greatest theatrical productions of the period. The grand festivities organized under Louis XIV interlaced fireworks, floats, ballets, and re-enactments of chivalric games with original plays produced on stages harmoniously set in the gardens or courtyards of the palace [FIGURE 34]. Indeed, the great masterpiece of French theater, *Tartuffe*, was first staged by Molière not on the Paris stage but instead in the luxurious gardens of Versailles, where, after a successful performance, it was immediately banned for the next five years on the charge of suggested impiety. Louis XIV found *Tartuffe* amusing enough for the enlightened and gallant court, but feared the play's denunciation of religious hypocrisy would be dangerous for the wider public that frequented Paris theaters. The Sun King understood how potent the theater was, and how great an attraction it had for aristocrats and bourgeois alike.

Reverse cover

Figure 34

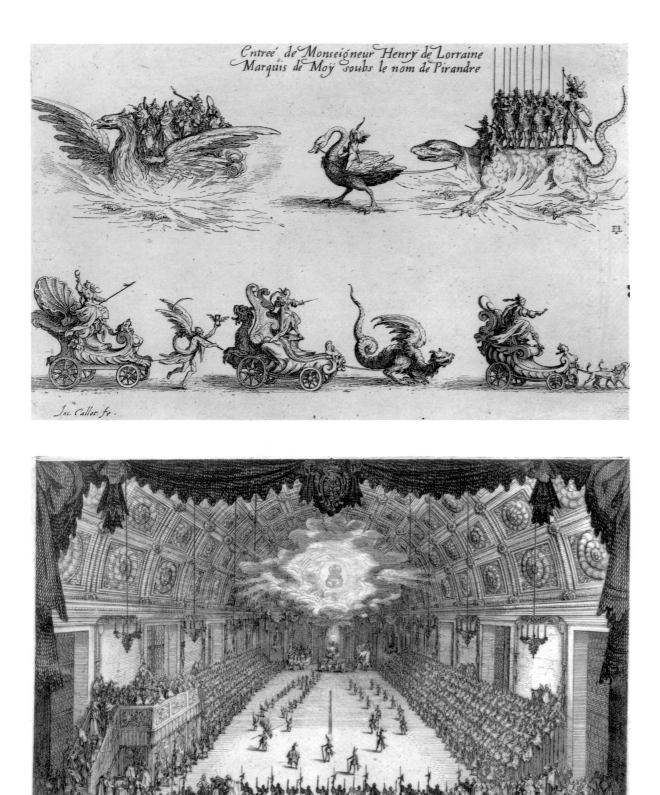

Entreé de Monseigneur Henry de Lorraine
Marquis de Moÿ soubs le nom de Pirandre

Jac. Callot fe.

Entreé de son Altesse a pied Jac. Callot In. et fecit

Figure 2
Jacques Callot, *Entry of Monseigneur
Henry de Lorraine*, 1627 (Cat No. 1)

Figure 3
Jacques Callot, *Entry of His Highness
on Foot*, 1627 (Cat. No. 3)

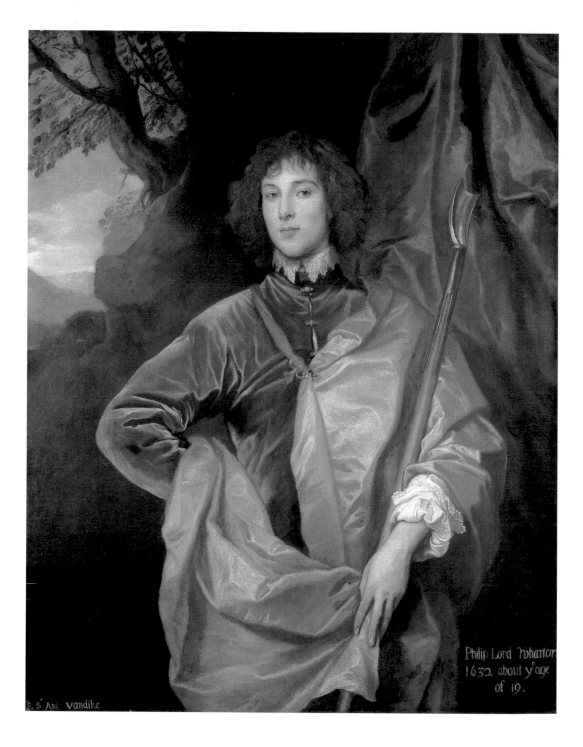

Figure 4
Anthony Van Dyck, *Philip, Lord Wharton*,
1632 (Cat. No. 16)

It is precisely the theater's new-found fascination for an elite, moneyed, and powerful audience that constitutes the final and no doubt most important contributing factor in the triumph of baroque drama. The elaboration of a civilization of manners in Renaissance Italy, exemplified by guidebooks to courtly refinement and culture such as Baldassare Castiglione's *Il Cortegiano*, spread across Europe as the former feudal and warrior class of the aristocracy was domesticated under centralized monarchies and modern states.[3] Concurrently, the rising bourgeoisie, often freed from day-to-day business concerns, increasingly mingled with the aristocracy while imitating its manners and decorum. The birth of this new large leisured class created a world in which distinction was no longer political or economic, but instead performative: an accomplished person of quality played his or her role in the social comedy with winning grace and wit. Theater became a metaphor for social role-playing, as well as a school where spectators learned to improve their own performance at Town or Court. It is here that the pastoral tradition plays a central role, one already suggested by its repeat appearances in Polonius's pompous catalogue ("pastoral, pastoral-comic, historical-pastoral . . ."). A first look at the sumptuous portrait of Philip, Lord Wharton by Anthony Van Dyck is enlightening here [FIGURE 4]. The aristocratic demeanor of the Stuart nobleman might seem to a modern eye oddly counterbalanced by the rustic shepherd's crook in his arm; likewise, the courtly lace collar is in apparent counterpoint to the casually bucolic robe. But for the baroque mind, pastoral simplicity and aristocratic cool were perfectly congruous. Indeed, there was no better way to display cultural refinement than to play the role of the idealized shepherd or shepherdess, lucky members of the rural leisure class with nothing more to do than compose love sonnets and improve their manners in pursuit of their beloved. Such is the tradition loosely adapted from ancient poetry and the late Greek pastoral novel, and reworked in modern prose by writers like Torquato Tasso, Sir Philip Sidney, and Honoré d'Urfé. But even more than these romances, it was the dramatic enactment of pastoral dialogue on stage, enriched by bucolic costumes, sets, gestures, and singing, that most effectively drove this cultural craze. Battista Guarini's *Il Pastor Fido* of 1590 was an enormous international success, and for much of the next century Europe's theaters were overwhelmed with pastorals (the most famous treatment in English, though hardly a typical one, being *As You Like It*). Audiences throughout Europe modeled their social performance on the idealized pastoral roles portrayed on stage; in seventeenth-century Paris, leading salon members went so far as to salute one another regularly not by their names but by self-assumed pastoral pseudonyms. And throughout the century and well into the next, elites dressed up, or rather dressed down—playfully and elaborately down, of course—for portrait painters like Van Dyck so as to be captured for eternity transformed into their favorite pastoral character.

The example of Van Dyck's *Lord Wharton* illuminates the extent to which theater's hold on popular imagination extended its powerful influence on the visual arts. Of course, the dialogue between painting and theater is as old as the first aesthetic treatises from antiquity. Aristotle repeatedly compared the mimetic properties of painting and theater, paralleling, for example, tragic playwrights with flattering portraitists and comic playwrights with more satirical painters. The exchange between the two arts was strengthened in the Renaissance, though it was still largely painting, sculpture, and architecture that dictated their authority to the re-awakening

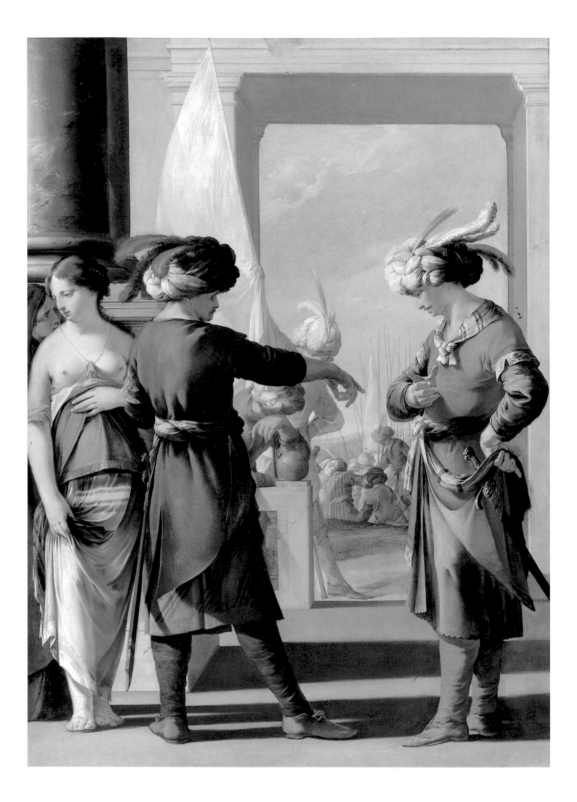

Figure 5
Laurent de La Hyre, *Panthea, Cyrus, and
Araspus*, 1631–1634 (Cat. No. 18)

art of drama: sixteenth-century Italian stage designers, for example, learned to apply to theater the rules of perspective derived from the visual arts. However, by the early seventeenth century, theater began to play a more powerful role in this creative exchange. The case of Laurent de La Hyre's magnificent treatment of the Panthea story is illuminating [FIGURE 5]. The story of Cyrus, king of Persia, and his beautiful captive, Panthea, menaced by an amorous lieutenant of the king, Araspus, was a favorite of the French stage in the decades leading up to the 1630s, when this painting was completed. The source for these dramatic adaptations was Xenophon's *Cyropaedia*, a popular ancient work, and de La Hyre may have been partly inspired by its prose. However, it is clear that the many theatrical productions at the time left their mark on de La Hyre's composition. Although numerous interpretations are possible for the specific scene depicted in the painting, it is clear that this is a moment of decision on the part of Cyrus, whose hand is dramatically pointing toward the soldiers in the background; it is a typically baroque gesture of spectacular magnanimity on the part of the hero, a highly public performance either of abnegation (choosing military duty over love—the army, to the right, over Panthea to the left)[4] or perhaps of clemency for the repentant Araspus. In any case, the painting bears all the marks of a theatrical production adapted to canvas. The foreground is a typical stage composition of four characters (a fitting number for a grand scene): two heroes, Cyrus and Araspus (one virtuous, the other flawed), and one heroine with her accompanying lady (a presence dictated by decorum, both on stage and off), here apparently a nurse. The simple but nobly proportioned architectural frame for the action perfectly reflects contemporary painted set backdrops. Of course the army massed behind the door would hardly be possible to recreate on stage. However, this background scene, so rigorously severed from the main action in the foreground, can be considered the exact equivalent of a perfectly banal dramatic device of the time: the narrated description of outside action delivered to the isolated world of the stage by an entering messenger. Like such a narration, the background vignette in de La Hyre's painting provides necessary information about a larger world without diluting the dramatic impact of a condensed emotional moment or disturbing the tightly blocked spatial intimacy shared by the key actors.

Given the theatricality of the painting, it is no surprise that another painting in the same series by de La Hyre was chosen as the frontispiece for the first edition of yet one more contemporary dramatic adaptation of the story, this one by playwright Tristan L'Hermite.[5] In this engraved form, the second painting became a forceful visual cue to seventeenth-century readers in their effort to stage the play in their minds while reading it. We arrive here at a dizzyingly intricate commerce between painting and drama: a play (in one version or another) inspires a canvas that then, as book illustration, inspires readers of the play, and perhaps even inspires future playwrights, directors, and set designers working on other dramatic versions.

The delicate balance of this dialogue between the arts, however, was tipped in theater's favor in the decades after de La Hyre's *Panthea*. Whereas up to this point the exchange between the visual arts and the theater seems mutually creative, after the mid-seventeenth century, and particularly in France, the growth of academies and the rigidity of neoclassical criticism promoted the reflexive application of the rules of theater directly to painting, placing the visual arts in submission to dramatic theory. Poussin,

for example, was praised at a 1667 session of Louis XIV's Académie de peinture et sculpture for what was described as his finest achievement: painting like a theoretically sound playwright. In the words of one of the speakers, the recently deceased and now deified Poussin "composed his work according to the rules which the art of poetry requires one to observe in composing plays for the theater."[6] According to the academic principles enunciated here, history painting, like tragedy, was to condense a story in order to dramatize the essential moment of the "change of fortune" of the hero—in Aristotelian terms, the *peripeteia*, a passing from happiness to misery, or vice versa. Narrative painting was transformed into a freeze-frame of a neo-Aristotelian drama, one designed to produce tragic pathos at a surprising shift in human fate.

A final return to Noël Hallé's *Joseph Accused by Potiphar's Wife* [FIGURE 1/ COLOR PLATE 1] will illustrate the power of this dramatic model for painting through much of the eighteenth century. The influence of Racine evoked earlier was all the more authoritative for a member of the Académie like Hallé, especially one undertaking a depiction of biblical history. Racine had become, with Corneille, the canonical example of French tragedy; not incidentally, Hallé's painting results from a mid-eighteenth-century academic revival of the genre so closely linked to tragedy, history painting. And in accordance with the rules of the art, Hallé depicted the climactic scene in which a dramatic change of fortune strikes the hero, Joseph. This explains why Hallé chose not the more frequently depicted scene in which Potiphar's wife attempts to seduce Joseph, but instead the later moment when she falsely accuses Joseph of seducing her; it is this second moment that seals the unhappy fate of the hero, who is sentenced to years in the dungeon. Hallé here not only showed the influence of French classical biblical tragedies, but also flirted with echoes of secular tragedy, particularly that of Hippolytus, similarly libeled by Theseus's wife, Phaedra (or, in the Racine version, by her nurse, Oenone). As in de La Hyre's *Panthea*, the essential elements of a theatrical production are spectacularly manifest in Hallé's composition. In a perfect reflection of the stage, the painting again represents four characters intensely interacting in an intimate space: the wife and her servant (here holding up Joseph's robe as evidence to corroborate her mistress's claim), Potiphar in shock at hearing the accusation, and Joseph, bearing the calumny with a rhetorical display of equanimity and submission worthy of the finest trained actor.

The mid-eighteenth-century revival of historical painting epitomized by *Joseph Accused by Potiphar's Wife* is in many ways the final celebration of dramatic painting, one that would reach an apotheosis with the early works of David. However, as the century wore on, theater increasingly lost its centrality in the cultural imagination. The growth of a wider middle-class reading public, often more domestic than worldly, promoted the novel as a conveyer of passions and ideas—and as a means to literary success. Reading in intimacy seemed suddenly more thrilling than sharing the experience of a theater audience. A concurrent new interest in the interior life, exemplified by Rousseau and other pre-Romantic writers, also led to a devaluation of the theater; the passions it once so seductively portrayed on stage began no doubt to appear too public, too conventional, too rhetorical. Of course new theatrical forms evolved, such as the bourgeois drama so effectively translated to canvas by painters like Greuze. Nevertheless, by the beginning of the nineteenth century, great writers like Goethe and

Figure 1

de Musset would create masterworks of theater without any immediate prospects for staging; their audience was found not at the playhouse but in an armchair at home. The power of plays naturally lived on, but the age of theater drew to a close.

1 Blaise Pascal, *Pensées*, Brunschvicg edition, no. 11 (Paris: Classiques Garnier, 1958) (unless otherwise noted, all translations are by the author).

2 See John R. Dunbar's account, *The Combat at the Barrier* (Pasadena, Calif.: Grant Dahlstrom, 1967).

3 See Norbert Elias, *The Civilizing Process*, trans. Edmund Jephcott (Cambridge, Mass., and Oxford: Blackwell, 1994).

4 This is the perspective offered by J. de Vazelhes; see Susan Wise, catalogue entry in *French and British Paintings from 1600 to 1800 in The Art Institute of Chicago: A Catalogue of the Collection*, ed. Larry J. Feinberg and Martha Wolff (Chicago: The Art Institute of Chicago, 1996), 85.

5 On the relationship of de La Hyre's painting to the frontispiece, see the remarks by Marc Fumaroli and Pierre Rosenberg in *La Peinture française du XVIIe siècle dans les collections américaines*, ed. Pierre Rosenberg (Paris: Editions de la Réunion des musées nationaux, 1982), 26–27 and 248–49.

6 From a discourse on Poussin's *Fall of Manna in the Wilderness*, as reported in the *Conférences* by André Félibien, quoted in Rensselaer W. Lee, *Ut Pictura Poesis: The Humanistic Theory of Painting* (New York: W. W. Norton & Company, 1967), 62. See also Lee's commentary on the hegemonic influence of neoclassical dramatic theory on painting at the time (61–65).

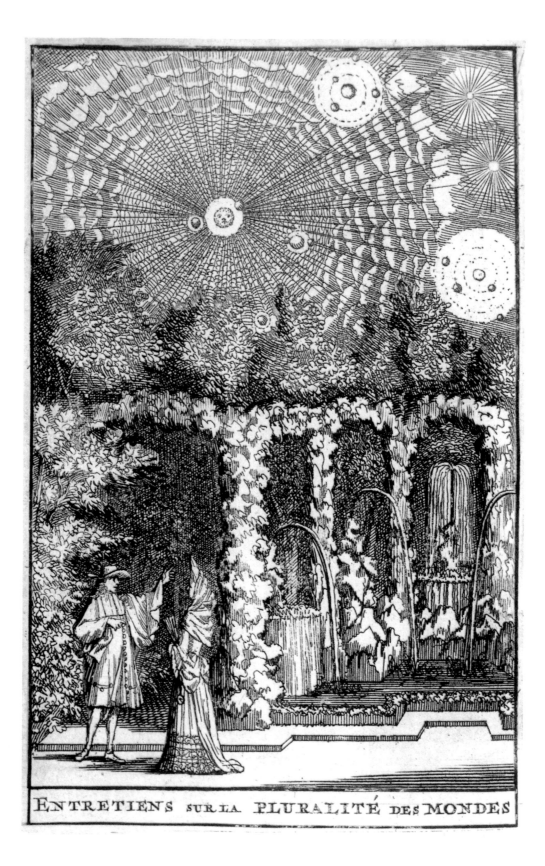

Figure 6
Bernard le Bovier de Fontenelle,
Frontispiece from *Entretiens sur la
pluralité des mondes*, 1701
(Cat. No. 28)

BAROQUE SPACE
and the Art of the Infinite

ROBERT S. HUDDLESTON

THE ART HISTORIAN JOHN RUPERT MARTIN wrote that the baroque was an age pervaded by a sense of the infinite. In the seventeenth century, "science, setting out from the Copernican hypothesis that the earth is only one of the planets in the solar system, revealed the homogenous structure of the whole physical universe."[1] Indeed, by the second half of the century, most thinkers readily acknowledged what Giordano Bruno had suggested in 1584: that the universe was infinite, containing a multitude of other suns around which revolved countless other planets. The concept of infinite space generated great excitement and equally great anxiety. In the mid-seventeenth century, Blaise Pascal wrote in his *Pensées:* "When I consider the short duration of my life, swallowed up in the eternity before and after, the little space which I fill . . . engulfed in the infinite immensity of spaces of which I am ignorant and which know me not, I am frightened, and am astonished at being here rather than there."[2] Bernard le Bovier de Fontenelle, whose *Entretiens sur la pluralité des mondes* (*Conversations on the Plurality of Worlds*) [FIGURE 6] became an overnight sensation in 1686, expressed quite a different attitude. "As for me," says Fontenelle's *savant* to the Marquise de G., his interlocutor, "I feel entirely at ease. When the sky was only a blue vault, with the stars nailed to it, the universe seemed small and narrow to me; I felt oppressed by it. Now that they've given infinitely greater breadth and depth to this vault . . . it seems to me that I breathe more freely, that I'm in a larger atmosphere, and certainly the universe has a greater magnificence."[3] Fontenelle's words, and Pascal's, remind us of what we appreciate in the great art of the baroque period—that combination of exhilaration and foreboding, distinct yet inseparable from one another, which so characterizes the products of the age.

The sense of awe peculiar to baroque art resulted from a revolution in the style and manner of representing space. The artists of the seventeenth century inherited from the Renaissance the idea perhaps best expressed by Leonardo da Vinci that "the first object of the painter is to make a flat plane appear as a body in relief and projecting from that plane"; or, in other words, to give the painted object a three-dimensional reality. Baroque artists extended the idea of giving life to the canvas still further. The object was meant not simply to exist in three dimensions but to *move*. ("Però si muove" ["But it does move!"] was Galileo's alleged defense before the Vatican Council.)[4] Just as seventeenth-century science introduced motion into our understanding of the physical universe, artists introduced motion into their work, so that space extends into the fourth dimension of time. Baroque art endows the objects it represents with a sense of often extraordinary weight and mass. It conveys a palpable illusion of physical

13

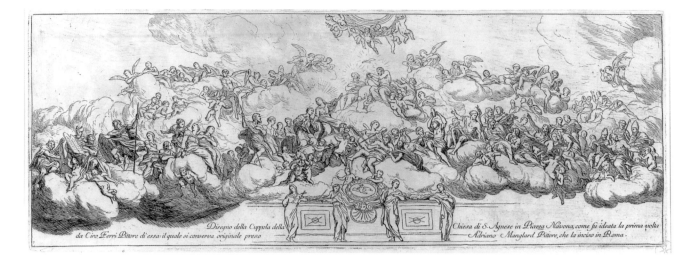

Disegno della Cuppola della ... Chiesa di S. Agnese in Piazza Navona, come fu ideata la prima volta da Ciro Ferri Pittore di essa il quale si conserva originale preso ... Adriano Manglard Pittore, che la inciso in Roma.

Figure 7
Adriano Manglard (after Ciro Ferri), *Design for the Cupola of Sant'Agnese, Rome*, mid-18th century (Cat. No. 26)

presence. Viewers often notice, for example, the fleshiness of Peter Paul Rubens's nudes or the massiveness of Bernini's famous colonnade at St. Peter's basilica in Rome. The great art critic Heinrich Wölfflin captured another important quality of baroque art in his description of the staircase leading up to the Roman basilica which, he said, "looks like some viscous mass slowly oozing down the slope."[5] Baroque art produces an illusion not only of presence but of motion in the sense that a physicist would understand it: the displacement of a body with mass through three-dimensional space over time. In this sense, baroque art is theatrical: the illusion of motion produces an effect that is both figuratively and literally *dramatic.* The theater, too, is a visual art. At the same time that painters were experimenting with novel effects that suggested movement on canvas, the use of perspectival scenery became common in Europe. Both art forms rely on *trompe l'oeil* devices, on illusion—tricks of light and the clever placement of drapery, for example—to heighten the viewer's sense of the reality of what is depicted.

The dynamism of baroque art is all the more aesthetically astonishing given the apparent size of the objects that are set into motion. In Adriano Manglard's *Design for the Cupola of Sant'Agnese, Rome*, after a work by Ciro Ferri [FIGURE 7], six putti hold aloft a large garland near the top of the composition, while the clouds depicted below support a vast crowd of figures, from the angels hovering just below the putti to the armed figure bearing a spear and a large shield at the far left. The figures are arrayed in a wide pyramid that finds its apex at the putti bearing the garland. The large, sloping structure gives the impression of either gradual ascent or slow, viscous descent; the whole composition, not merely individual objects, is set in motion. We are uncertain whether the figures will float aloft into heaven or slide into the space of the onlooker, so precariously are they balanced. This tension and uncertainty add to the allure of the work.

The space of baroque art is projective. Within the picture, everything recedes toward a vanishing point, plunging into the depths of the pictorial space with exaggerated velocity. The represented objects simultaneously invade the space of the onlooker. Baroque art unites the painting and the viewer in a single coextensive space, creating the illusion that the image is as real as its beholder and that the pictorial

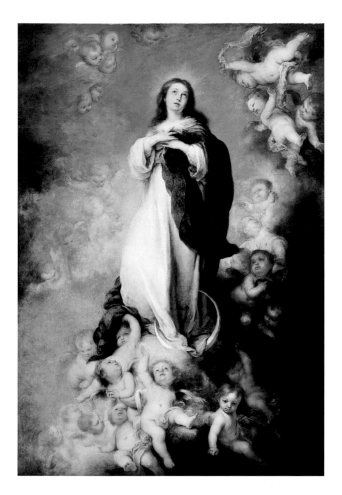

Figure 8
Bartolomé-Esteban Murillo,
The Immaculate Conception, oil on
canvas, 1678. Madrid, Prado Museum
(Not in exhibition)

space extends infinitely. Martin suggests that this sense of pictorial space is analogous
to the concept of infinity that was gaining hold during the seventeenth century. In cer-
tain paintings, such as Bartolomé-Esteban Murillo's *Immaculate Conception*
[FIGURE 8], "we . . . catch an echo of the 'infinite immensity of spaces' which evoked
such feelings of awe in Pascal."[6] In Pietro Aquila's engraving after Carlo Maratta's
Blessed Virgin in Glory [FIGURE 21], as in Murillo's canvas, the Virgin raises her
eyes toward an unseen heaven. The pictorial space is extended upward by the Virgin's
gaze and outward by the reverential figures at the base of the work, who seem to lean
out into the space of the onlooker, creating two trajectories of infinite expansion.

Likewise the stunning *Design for a Ceiling* [FIGURE 9/COLOR PLATE 2] by
the Austrian artist Daniel Gran produces a sense of infinite recession. Gran places us
below the vault, looking upward past the edge of a fictive dome into a space that
seems to have become transparent, open to the sky. A group of figures, one of whom
dangles his leg into the space of the building, perches on the edge of the cornice; oth-
ers, on insectlike wings, hover below. These fantastic figures are able to pass through
the frame within the picture, an effect that endows the world depicted on the ceiling
with a reality of its own, coextensive with the reality of the space below it. Fontenelle
suggested a similar breaking down of boundaries in the *Entretiens*, where he
addressed the possibility of visiting the moon, the planets, and the many other worlds
that we see suspended above us in the night sky [FIGURE 10]. There, his *savant* tells
the Marquise, we would no doubt find extraterrestrial beings who would seem fan-

Figure 21

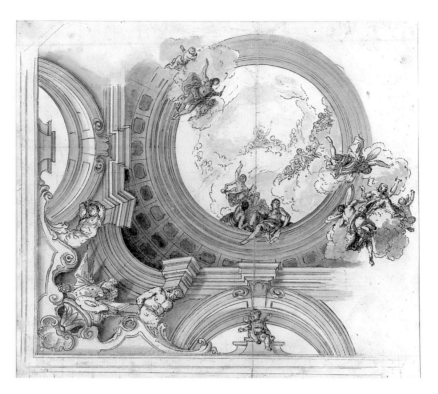

Figure 9
Daniel Gran, *Design for a Ceiling*,
circa 1720–1757 (Cat. No. 27)
See Color Plate 2

Figure 10
Bernard le Bovier de Fontenelle,
pl. 1 from *Entretiens sur la pluralité
des mondes*, 1701
(Cat. No. 28)

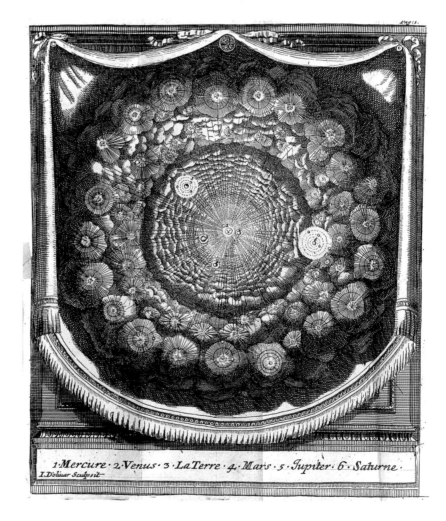

1.Mercure · 2.Venus · 3.LaTerre · 4.Mars · 5.Jupiter · 6.Saturne.

tastic to us; we would appear equally strange to them. Gran's winged creatures stare down at us with a mixture of interest and amusement, mirroring our own reaction to their curious appearance.[7]

Fontenelle's speculation about the possibility of communication between separate worlds is a common motif of baroque art—equally present in architecture and interior design, as Gran shows us. A wall is never simply a wall, nor a ceiling, a ceiling. Each architectural element is extended beyond its functional duty as a shield from the hostile elements. The aesthetic component of the object, its form, overtakes its function. A wall or a ceiling becomes a possible opening onto the reality which it occludes. In Carlo Innocenzo Carlone's study for *Parnassus Triumphant* [FIGURE 11/COLOR PLATE 3], an illusionistic view up toward the heavens erases the upper boundary of the room and provides an unobstructed view of the gods in their celestial domain. This fiction of expanse was aided by an approach to form in which architectural borders exist only to be superseded—as in Manglard's image of a cupola design, where the figures extend beyond the pediment—and one space overflows into another. The effect of movement and action was now more important than the effect of symmetry and balance that had dominated the art of the Renaissance. Baroque artists aimed to undo the classical unity of form and function, to unbalance the composition and achieve the impression of movement and space that the new age demanded. Thus, Wölfflin writes:

> The church interior, [the baroque's] greatest achievement, revealed a completely new *conception of space directed towards infinity:* form is dissolved in favour of the *magic spell of light*—the highest manifestation of the painterly. No longer was the aim one of fixed spatial proportions and self-contained spaces with their satisfying relationships between height, breadth and depth. The painterly style thought first of the effects of light: the unfathomableness of a dark depth, the magic of light streaming down from the invisible height of the dome, the transition from dark to light and lighter still are the elements with which it worked.
>
> The space of the interior, evenly lit in the Renaissance and conceived as a structurally closed entity, seemed in the baroque to go on indefinitely. The enclosing shell of the building hardly counted: in all directions one's gaze is drawn into infinity. The end of the choir disappears in the gold and glimmer of the towering high altar, in the gleam of the "splendori celesti," while the dark chapels of the nave are hardly recognizable; above, instead of the flat ceiling which had calmly closed off space, loomed a huge barrel-vault. It too seems open: clouds stream down with choirs of angels and all the glory of heaven; our eyes and minds are lost in immeasurable space.[8]

Wölfflin discovered the greatest achievement of baroque art at the point where architectural design, with its functional imperatives, met religious art, with its propensity for symbolic statement. In great examples like Bernini's colonnade for St. Peter's in Rome, the two aspects of the baroque—its purely concrete or stylistic qualities and its idealized purpose—were joined in aesthetic unity, in a kind of *Gesamtkunstwerk* (total work of art).

Figure 11
Carlo Innocenzo Carlone,
Study for *Parnassus Triumphant,*
circa 1720–1730 (Cat. No. 25)
See Color Plate 3

Contrast is the primary tool through which baroque art prompts a sensation of the infinite in the mind of the beholder. The infinite cannot of course be shown. It must be suggested or implied. What baroque art conveys is an impression, an illusion of infinite space, of movement into boundless depths, by suggesting the existence of what finally remains unseen. Contrast of light and dark, or chiaroscuro, gives space particular qualities. It accentuates the illusion of depth, giving the objects depicted a greater sense of mass and weight while simultaneously heightening their three-dimensionality, making them appear to jump out of the picture frame, or in the case of sculpture or decoration, out of the immediate space that "contains" them. It gives the image dramatic possibilities that steady, even illumination precludes. Like the lighting in films, chiaroscuro in painting works directly upon the spectators' emotions. Curiously, perhaps because the technology was lacking, stage spectacles were slow to adopt the use of dramatic lighting.[9] Other techniques for at once expanding and occluding the pictorial scene in order to create or heighten a mood, such as the use of drapery, found their way into both the visual arts and stage spectacles. It is possible to look at theater in the seventeenth century, particularly its embodiment on the stage, as a branch of the visual arts. The scene was framed and the actors were often described as "painting" their characters.

It is less important, however, to draw a direct analogy between the theater and the other visual arts than to suggest that the painter's use of chiaroscuro and the resulting sense of space were—in an important sense—theatrical. The effect of contrast, of drapery, of the deliberate bending and distortion of space was to create a dramatic illusion that suggests the existence of the unseen. Drapery foils the eye's natural

curiosity, leading the viewer to imagine that it covers something. The gaze of figures in a picture, as in the case of Pietro Aquila's Virgin Mary who looks off into an unseen space, convinces us of the reality of that which we cannot see. Such figures deceive us as certainly and as pleasurably as the actors on a stage convince us of the existence of Hamlet's Denmark or Phèdre's Greece. This is not to say that what is represented has no real reference—Denmark and Greece are clearly real places (although Hamlet and Phèdre are not, at least in our conventional understanding of the matter, real people)—only that the object being represented is not *present* in the painter's or the actor's depiction of it; that Denmark, in other words, is not really on the stage; that Murillo's painting presents an image of the Virgin, not the Virgin herself. And yet the success of the depiction depends in some sense on our believing in its presence. It hinges upon the painting's ability to get us to believe, not in the reality, but in the presence of what it depicts—the presence, for example, of a three-dimensional living body within the surface of the painting, or of the infinite extensibility of the illusory pictorial space—if only in ghostly form. At this, the baroque excels.

1 John Rupert Martin, *Baroque* (New York: Harper & Row, 1977), 155.

2 Blaise Pascal, *Pensées,* trans. W. F. Trotter (New York: Modern Library, 1948), quoted in Martin, 155.

3 Bernard le Bovier de Fontenelle, *Entretiens sur la pluralité des mondes* (1742; Paris: Marcel Didier, 1966), 135; *Conversations on the Plurality of Worlds,* trans. H. A. Hargreaves (Berkeley: University of California Press, 1990), 63, trans. mod. by author.

4 Galileo was of course referring to the motion of the earth, which, as he recognized, revolves around the sun. The Vatican Council considered any view that opposed the traditional conception of the earth as the center of creation to be heretical and punishable by death. Giordano Bruno was burned at the stake in 1600 for his similarly unorthodox views. Galileo's works were condemned, but because he publicly renounced his ideas at the insistence of the Council, he escaped Bruno's fate. For a discussion of the influence of Galileo's discoveries in astronomy on the arts, see Eileen Adair Reeves, *Painting the Heavens: Art and Science in the Age of Galileo* (Princeton, N.J.: Princeton University Press, 1997).

5 Heinrich Wölfflin, *Renaissance and Baroque,* trans. Kathrin Simon (Ithaca, N.Y.: Cornell University Press, 1966), 45.

6 Martin, 155–56.

7 There was good reason to draw an analogy between heavenly creatures—angels, putti, cherubim, and so on—and the inhabitants of other worlds, i.e. extraterrestrials as Fontenelle would begin to conceive of them. Heaven, the celestial sphere, had since ancient times been located by theologians in the firmament of stars surrounding the earth and its neighboring planets.

8 Wölfflin, 64–65. One of Wölfflin's principal contributions to art theory and criticism was the contrasting of two fundamental categories of representation, the linear and the painterly. Very generally speaking, he characterized Renaissance art as "linear"—clear, closed, and self-contained—while baroque art exemplified the more expansive painterly mode.

9 Inigo Jones's experiments in England are an exception. For a discussion of the use of theatrical lighting in English court masques, see *The Theatre of the Stuart Court,* ed. Stephen Orgel and Roy Strong (Berkeley: University of California Press, 1973).

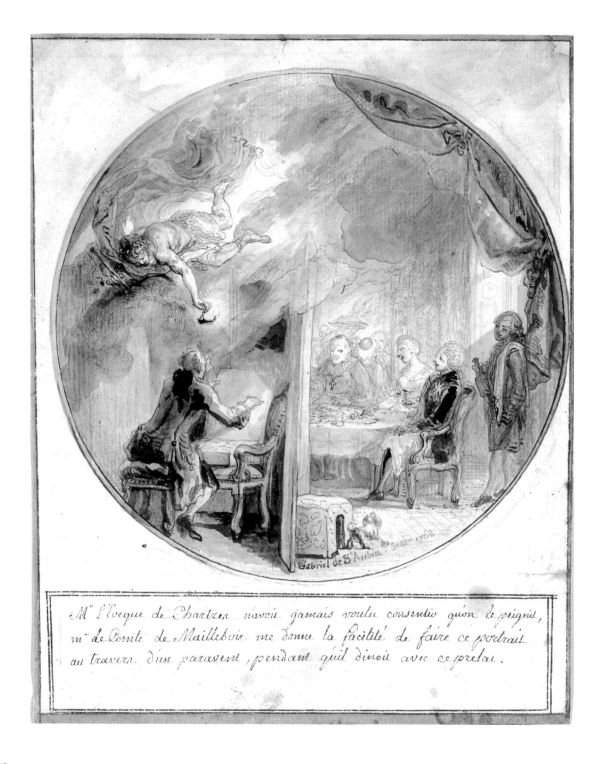

Figure 12
Gabriel-Jacques de Saint-Aubin,
Gabriel de Saint-Aubin Executing
the Portrait of the Bishop of Chartres,
1768 (Cat. No. 7)

REPRESENTATIONAL THEORY
and the Staging of Social Performance

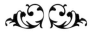

JOSH ELLENBOGEN

IN A BANQUET HALL, in a convivial setting, a group of figures has gathered [FIGURE 12]. Smiling at one another, looking at one another, they take their places at what appear to be two tables and exchange conversation over their meal. Based on the figures' dress and general aspect, one may imagine the substance of their talk is refined; the meal's evident expense and the presence of a manservant on the far right side would seem to attest to their nobility. The figures exchange light banter and pleasantries, enjoying the opportunity for graceful social intercourse that the banquet scene affords. Yet immediately the spectator senses that something sets this particular dining experience apart. An artist, working with his back to the viewer, occupies a hidden enclosure that takes up fully half the scene, oddly and glaringly cutting it in two. The screen that shields the artist from the diners, situated in almost the exact center of the composition, enforces a marked separation of the view, throwing the space of social gathering and the space of representation into realms that appear disjunct. An inscription below the picture provides a rationale for this unusual scenario: "Monsieur the Bishop of Chartres had never consented to be depicted. Monsieur the Count of Maillebois gave me the chance to do this portrait through a screen while he dined with the prelate."[1] This remarkable image of hidden depiction, then, basically amounts to a monumental joke played on the hapless priest, one that mirrors, perhaps, smaller ones taking place at the table, in the elegant social discourse of the diners.[2] A muse with an oil lamp hovers over the artist, casting light upon his improvised easel, while at the same time, from an unseen point of entry on the right side, a second source of light illuminates the artist's subject, the prelate. By contrast, the count and the manservant behind him, as well as the artist, remain sheltered in darkness.

Gabriel-Jacques de Saint-Aubin's depiction of covert portraiture can be seen as a nodal point for the baroque understanding of representation. It mobilizes some of the most central concerns, oppositions, and stresspoints within this understanding, brings them to the surface, and exposes them to sight. As the foregoing discussion intimates, Saint-Aubin's rendition of these tensions seems built into the very structure of his drawing. Riven in two, the drawing itself fundamentally consists in the juxtaposition of separate spaces. Further, the terms of the work's division—between the action of social exchange and the action of artistic depiction—allow viewers to approach the specific nature of the baroque's representational stresspoints. These stresspoints concern the purpose of representational depiction, the status of art in general, and the

peculiar tasks that portraiture must discharge. As this essay will show, all of these stresspoints are related to the distinction between the social and the artistic, the nature of the distinction between them, and whether or not one chooses even to make the distinction. This discussion, which takes Saint-Aubin's work as its point of departure, has equal bearing on theater, for baroque thought not only has the routine habit of conceiving painting through metaphors of theater and theater through metaphors of painting. It also duplicates the representational tensions of the one in the other, treating both theater and painting as sites of the same conflicts. Saint-Aubin's work is a type of emblem for these tensions, revealing important aspects of theater's and painting's cross-conceptualization. Such an intersection of theater and painting derives from the unprecedented prominence that the stage enjoyed in the baroque era. In this age of theater, the stage became a favored vehicle for imagining the world. Quite apart from its position in the understanding of representation, the baroque theater played a central role in the understanding of social intercourse, human action, and even the nature of the self. That Saint-Aubin's work should throw such a strong light on the intersection of theater and painting, and that it should do so in the context of depicting the social world, lets this drawing of 1768, the very end of the era generally termed "baroque," crystallize some of the era's deepest tensions and concerns. It does so, above all, in regard to how the baroque answered the basic question, "what is it to represent something?"

A particular formulation in Aristotle's *Poetics* has a central role to play here, given the prestige and influence that it historically enjoyed, as well as the significant modifications that the baroque age was to visit upon it.[3] In an argument that was to inflect for centuries discussions of genre and representation, Aristotle claimed that one could distinguish between different genres based on their approaches to the depiction of human individuals. According to Aristotle, art could represent men better than they are, worse than they are, or just as they are.[4] Traditionally, tragedy sought to depict individuals as better than they are, while comedy trafficked in the portrayal of individuals as worse than they are. Most significantly, even in Aristotle's own original formulation, the third mode—in which artistic representation does not meaningfully depart or diverge from its object—never receives fuller qualification. This third mode remains an unfilled slot in the *Poetics*, and a possibility that medieval and Renaissance commentators left largely undiscussed.[5]

One of baroque theory's fundamental departures from previous aesthetic debate consisted in a sustained and anxious scrutiny of this empty slot. More precisely, baroque commentators considered not only how one might depict men just as they are, but what the stakes involved in such a move might be. Critical voices in the seventeenth century came to see these stakes as consequential indeed, concerning no less than the purpose and character of artistic portrayal, and the question haunted much of baroque aesthetic debate. Much of the heat surrounding this debate proceeded from the opening of a novel gulf in seventeenth-century thought: the traditional privileges of art, such as idealization, typological representation, and aesthetic amplification of the object, were set against the humbler work of accurate portrayal, faithful transcription, and depiction of what one actually beheld. Artistic imagination either could have free reign, the capacity to idealize and beautify the model in reference to an intellectual type, or it could restrain itself, aiming to do no more than render the true,

understood here to be the visually present.[6] Partisans of the first approach attacked practitioners of the second as mere copyists, while these artists in turn derided their critics as unskilled draftsmen, ill prepared for the more rigorous challenges of duplicating nature.[7]

The debate sketched above had a presence in discussions of both theater and painting. Whether portraits appeared in theatrical or pictorial form, all were subject to the constraints of this dispute. The work of the satirist Molière provides especially telling examples in this context, since it became something of a commonplace in baroque discussion that his comic plays were fundamentally a series of portraits, copied and stitched together directly from life, without the mediation of artistic selection and control.[8] The following excerpt about Molière from Jean Donneau de Visé's 1663 play *Zélinde* underscores the intersection of drama and painting when it comes to such pillaging and copying. The characters Argimont and Oriane explicitly address the matter, describing Molière's compositional method as follows:

> ARGIMONT: [Molière] had his eyes glued to three or four people of quality. . . . He appeared attentive to their discourse and it seemed that, by a movement of his eyes, he looked right into the bottom of their souls in order to see what they were saying. I even believe that he had some tablets and that, with the help of his coat, he wrote, without being seen, all the most remarkable things they said.
>
> ORIANE: Maybe it was a crayon, and he drew their expressions in order to represent them naturally on stage.
>
> ARGIMONT: If he did not draw them on the tablets, I don't doubt that he printed them in his imagination. He is a dangerous person.[9]

That Molière might copy down such portraits and words while engaged in social intercourse, and that he should do so secretly, like the artist in the Saint-Aubin drawing, is a point that will be considered in a moment. At present, what matters is the implication that Molière's work—as a species of comedic portraiture that allegedly goes so far as fully to copy the appearance and actual conversations of those it satirizes—represents an art form that duplicates rather than amplifies its subjects. Despite the fact that Molière's actual working method probably bore little resemblance to the procedure that Donneau de Visé delineated, symbolically it stood for a hypertrophied form of artistic replication in the trajectory that structured seventeenth-century understandings of representation.

One can locate many of the works in the present exhibition on this representational spectrum so central to baroque theory. For example, the drawing *Peasants Drinking from a Cask* attributed to Isaac Van Ostade [FIGURE 13], Jacques Callot's image of two grotesque dancing figures from his series of *Capricci* [FIGURE 14], and Anthony Van Dyck's wonderful *Philip, Lord Wharton* [FIGURE 4] all seem to attempt, albeit in vastly different ways, to provide the spectator with more than a visual transcript of the world. The works by Van Ostade and Callot engage in comedy's traditional vocation of picturing individuals as worse than they are. Callot's figures are amusing in their very deformity. A lute player with legs too short for his body strikes a tune, while an old crone with a head too large for her torso awkwardly raises

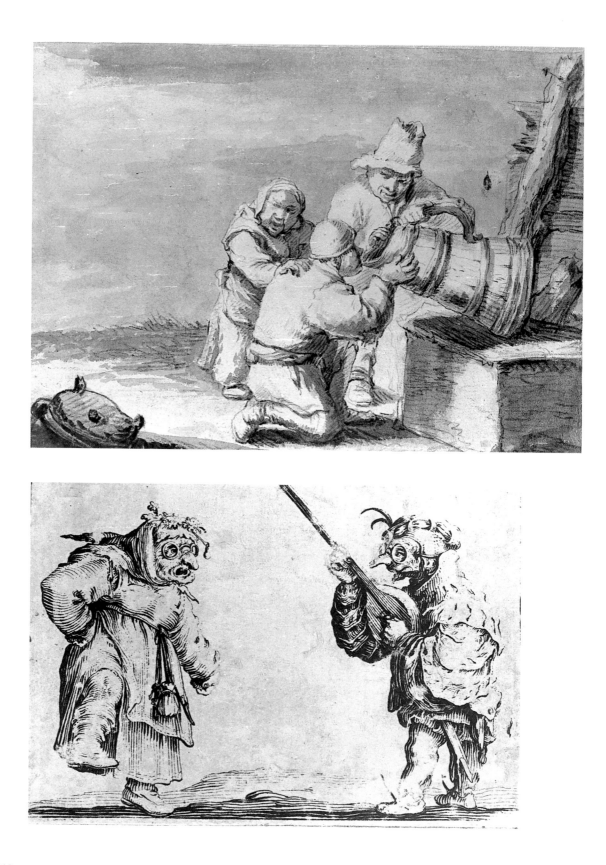

Figure 13
Attributed to Isaac Van Ostade,
Peasants Drinking from a Cask, 1647
(Cat. No. 9)

Figure 14
Jacques Callot, *A Man Playing a
Lute while a Woman Dances*, 1617
(Cat. No. 8)

a leg in a gesture she apparently means to be a dance. Van Ostade's peasants, for their part, seem to belong to a race of comical, lecherous dwarfs. A stunted figure leers out at the viewer; his companions jointly attempt to get at the contents of a cask of liquor. That the cask is so large, and that the job of consuming it should require a pair working in tandem, only enhances the midget-like appearance of the peasants. Unless one has very strange beliefs about how baroque peasants looked, one cannot take Van Ostade's and Callot's kind of truth-telling as having much to do with the visual aspect of depicted objects. Rather, both artists strove to picture their subjects in terms of their general essence, which in turn derives from the type—in this case the peasantry— to which they belong.

Van Dyck's *Philip, Lord Wharton* also strives to do more than copy the visual aspect of its subject. While it is too much to say that the portrait presents Lord Wharton as necessarily better than he is, it does deploy the trappings of arcadian and pastoral simplicity to assimilate him to a flattering type of humanity, quite possibly the contemporary ideal of the *honnête homme*.[10] The seventeenth-century notion of *honnêteté* has two dimensions, both of which are relevant to the present discussion. On the one hand, it denotes ease, directness, and a lack of affectation in manner. This species of man had no apparent recourse to artifice or self-composition in his bearing or social interaction, but carried himself in a way that was the perfect picture of the genuine, casual, and unpretentious. Such an individual embellished himself and his conversation just enough to be engaging, but never so much as to seem precious or affected. Certainly, Van Dyck's decision to insert his wealthy patron into a rustic environ derived from a desire to treat Lord Wharton as an example of such a flattering type. On the other hand, one needs to bear in mind that this perfect picture of the genuine and direct was precisely that, a "picture." That is, the baroque age tended to conceive the individual, above all in social interaction, as a construct, or product of art, whose image in the eyes of others was subject to manipulation and composition. The *honnête homme* distinguished himself from his peers not by the absence of art in his carriage and aspect, but by making it exceptionally difficult for observers to catch that art. In a way that parallels certain tenets of baroque aesthetic theory, the individual in social interaction was never to reveal the constructive means he deployed to make his image. The standard to which the artwork and the social being ultimately aspired was largely the same: an artfulness that did not reveal itself in too overt a fashion. Although Van Dyck hinted at this artfulness with his subtle references—in costume and setting—to pastoral ideals and aristocratic role playing (see Norman, p. 7), the sitter in this portrait is the embodiment of both perfect construction and seeming casualness, the very type of *honnêteté*.

Franz Anton Maulbertsch's work, in contradistinction to that of Callot, Van Ostade, or Van Dyck, exemplifies a very different aesthetic approach. As a work "that mirrored the world in which they [the members of its audience] lived," its attraction had little to do with typological inquiries or commentaries.[11] In *The Pancake Woman* [FIGURE 15] and *The Sausage Woman* [FIGURE 16/COLOR PLATE 4], Maulbertsch did not attempt to show, by incisive departures from surface appearances, the essence of these fairly humble individuals. Eschewing Callot's or Van Ostade's drive to show the ridiculous inner nature of those pictured, Maulbertsch held himself to the humbler goal of trying to copy a visual record. He primarily attempted to duplicate

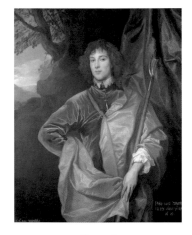

Figure 4

Figure 15
Franz Anton Maulbertsch,
The Pancake Woman, circa 1785–1790
(Cat. No. 5)

Figure 16
Franz Anton Maulbertsch,
The Sausage Woman, circa 1785–1790
(Cat. No. 6)
See Color Plate 4

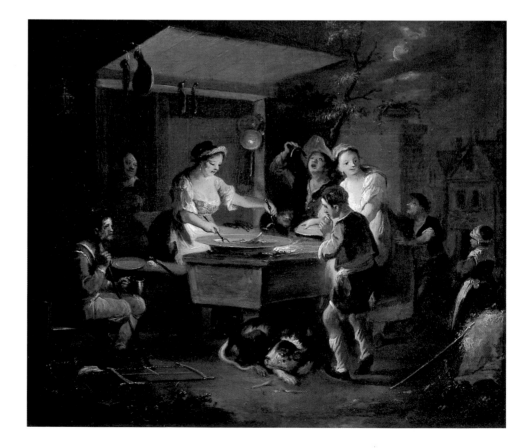

the sort of scenes and views with which his audience would already have been famil-
iar because they were the scenes and views that comprised the audience's life. As
though taking a species of visual dictation, Maulbertsch tried to amass, in works one
might best view as compilations, observations and details taken directly from the
world about him. While these particular canvases depict peasants for the enjoyment
of a middle-class public, the family of works to which they belong strives to please its
audience by copying for the audience its own world.

At times, the pleasures of duplication go so far as to permit the audience to par-
ticipate in its own depiction. The work of Molière represents the finest theatrical spec-
imen of this scenario.[12] Donneau de Visé's description of Molière's working method
again provides a key. According to the critic, not only did Molière secretly copy down
the words and physical appearance of those he met in society, these people—who
would comprise the eventual audience of his plays—actually sent him material in the
form of dialogues and incidents from their own lives that Molière proceeded to incor-
porate into his own work:

> All those who give him memoires want to see if he uses them well;
> some go there [to his plays] for half a verse, others for a word, others
> for a thought which they pray him to use. . . . This justly makes one
> believe that the great number of self-interested theatergoers who go to
> these plays is what makes them succeed.[13]

According to such an argument, Molière's satires benefited from his incorporation of
"accounts of all that was happening in society, and portraits of their [the audience's]
own faults, and those of their best friends, believing that they would be glorified by
having their impertinences recognized in his works."[14] Molière's work represented the
pinnacle of portraits that were radically non-amplifying in their descriptive endeavor.
Within the context of baroque discussion, Molière's status as copyist was such that he
let the subject he chronicled and depicted, the audience and its social world, literally
author itself. Although Molière, with his hidden pen and paper, may have added
observations of his own to his plays, one finds little indication in baroque discussions
of the author that his depictions diverged on any essential level from the models he
observed in society. Molière's satiric works thus amounted, in the mind of much of his
public, to a generic transcript of social perception and derision.

What made this radical aesthetic conception of duplication possible was the
baroque idea of social life and social interaction. As we have seen in the case of the
honnête homme, an individual's self-presentation was constantly subject to judgment
by others. If an individual was seen to carry and compose himself badly, if he was
clumsy in the art of self-presentation and self-construction, he became a potential tar-
get for derision and mockery. The stakes at play in such social evaluations were enor-
mous; since the individual's position was conceived in relation to others, his very
identity was on the line. These standards largely converged with the standards that
were brought to bear in the evaluation of a work of art. A striking passage from the
work of the seventeenth-century essayist Pierre Nicole throws light on this idea:

> Man does not form his own portrait on what he knows about himself
> through himself, but also by seeing the portraits that he discovers in
> the minds of others. Because we are to one another like the man who

serves as a model in the Academy of Painting. Each of those who sur-
rounds us creates a portrait of us. . . . But what is most significant in
this is that men do not simply make the portraits of others but that
they can also see the portraits that one makes of them.[15]

In Nicole's conception, an individual in the social world is a wanderer among a crowd
of portraitists—portraitists whose work will help determine that individual's under-
standing of himself. Perhaps because so much depended on one's ability to make the
right impression on others, baroque social existence came to resemble an unending
duel of rival portraitists. One never escaped the viciously discerning gaze of others,
nor the cutting remarks or savage depictions they might engender. It is not too much
to describe this social world as the endless circulation of warring satires. For this rea-
son, a satiric portraitist who sought to portray the social world had the option of lit-
erally copying from it: there was no necessary qualitative distinction between the
social and artistic worlds. By the same token, the personas of artist and socialite
sometimes appeared interchangeable. Thus it was possible at the time to believe that
Molière composed his plays as a social being, furtively copying the words and like-
nesses of those with whom he conversed and taking particular bits from the gossip he
received. To locate this method at one extreme end of the representational trajectory
discussed earlier, one must imagine an artist with a different aesthetic stratagem,
adopting a position more distant from the social and striving for an elaborative, speci-
fically artistic vision of his subject. At the very least, this artist might conceive his sta-
tus as creator as something meaningfully distinct and separate from his status as a
social creature.

As we turn our attention back to Saint-Aubin's scene of hidden portraiture, the
work appears to fall, at least initially, quite neatly into the same general slot occupied
by Donneau de Visé's vision of Molière's writings. Certainly, Saint-Aubin mobilized
the same understanding of social life, for he bluntly asserted that it is impossible to
escape from either the evaluative gazes of others, or from the resulting reports. The
bishop tried to hold himself aloof from this network of inspection, vicious discern-
ment, and reportage, and simply could not do it. The gaze of the world has a power
and presence that is inescapable, even for those who fancy themselves immune to it.

There is an even more telling resonance between Saint-Aubin's drawing and the
species of work that aspired, at least in the minds of contemporaries, to a generic
transcript of social inspection. While the portrait's subject is clearly unaware of the
artist's presence, he is hardly heedless of all the presences around him. Sitting at the
dinner table, engaged in social intercourse, the bishop would seem to be acutely aware
of the other diners. Presumably, he engages in the quintessentially baroque activity of
self-fashioning, composing himself in a way that he hopes will be to his advantage
(although his fear of portraitists suggests that he is doing a bad job of it). Since he is
already the object of social perception, one wonders why the bishop refuses to be the
object of artistic perception. Why must the artist's gaze be secret?

From a certain perspective, it need not be secret at all. Here, the relationship
between what goes on in the left side of the work and what goes on in the right side is
one of pure redundancy. The artist sees what everyone else does—an individual aware
of being seen, who tries to compose himself accordingly. Indeed, the artist is not even
an especially acute practitioner of a shared observational style, since the bishop's

clumsiness seems to be an open secret. The conspiring Count of Maillebois, for one, would appear to have realized this fact some time ago, which is why he finds it funny to have smuggled in the artist. Even the manservant standing behind the count seems to be a partner in the game that breaks down the barrier between the two sides of the work, between social observation and artistic depiction. He actually looks, with what appears to be a sly smile, in the direction of the artist. One might finally note that Saint-Aubin, as if to underscore the artist's embeddedness in the form of social observation taking place at the table, portrays himself working with his easel perched on a chair that he seems hurriedly to have snatched from the banquet. The baroque artist is apparently a dinner guest like any other.[16]

Yet Saint-Aubin's work does not lend itself to a resolution that is quite so tidy in the end. That is, for all of its suggestions that the artist serves merely to record the findings of a universally practiced species of inspection, the work also intimates a different possibility. Within the logic of the drawing, the artist does seem to have the capacity to elaborate or amplify his subject by means of unique and peculiar observational skills. Consider the muse-like figure that hovers over the artist as he works. In addition to the general suggestion that a special inspiration permits the artist to see in a way that departs from everyday perception, the muse's oil lamp has particular significance. While Saint-Aubin, like everyone else at the banquet, sees the bishop by the light that enters through the window, he sees the surface upon which he works by an entirely different light, one to which only he has access. Set apart in his own small enclosure, Saint-Aubin produces his drawing of the bishop by a light that does not enter into or mingle with the realm of social interaction. Although the artist may indeed perceive the world in approximately the same way as everyone else, his mode of vision diverges when it comes to making the world into art. The light that lets Saint-Aubin produce his image of the bishop on the page is entirely dissimilar from the light that lets the Count of Maillebois produce his own mental picture of him. The rift between the work's two sides that had seemed on the verge of closing now reappears. Although we cannot clearly discern what is on the artist's hidden sheet, the presence of the muse with the oil lamp makes it highly difficult to believe that the work will duplicate the social perception generated by all of the diners.

The image's tendency to revel in its own artificiality also implies that it is something more than a neutral observational transcript. Although a certain segment of baroque opinion held that this was the last thing a work of art should do, Saint-Aubin's drawing enjoys at least hinting at its own status as a contrivance. One of the most literal of these hints is the drape at right. Many of the works in the present exhibition, such as Van Dyck's portrait of Lord Wharton and Noël Hallé's *Joseph Accused by Potiphar's Wife* [COLOR PLATE 1], feature prominently placed drapery or curtains. Although one might suggest that these devices point to a parallel in the baroque between conceptions of theater and painting, the curtain in Saint-Aubin's work seems to have an added purpose. Most unusually, this particular curtain follows the outside edge of the composition, and even seems pinned onto it in two places, thus intruding into the world of the viewer. The artist's ironic assertion that the depicted world and the viewer's world are equally concrete—equally capable of supporting a heavy mass of fabric—calls attention to the drawing's identity as a piece of artifice.

Finally, the work proclaims its status as art by featuring a "portrait-within-a-portrait." As numerous scholars have noted, this type of scenario can open up an infinite regress or *mise en abyme*, an endless series of images within images that can also encroach on the viewer's own space.[17] In the case of the Saint-Aubin drawing, the unusual tondo format enhances this vertiginous sensation. Because the composition can be seen as a peephole, the viewer ends up spying on the drawing by an artist who is a spy and who appears here making another drawing, quite possibly of another spying artist. Apart from the joy of visual trickery it affords, this type of work strives "to demonstrate to us the powers of painting" and "the mysteries of art and its power of imitation."[18] For each element in Saint-Aubin's drawing that posits the interchangeability of artistic and social depiction, another element asserts the artwork's distinctiveness. Thus it becomes impossible to maintain that this work ever resolves the representational tension in the baroque regarding what art must do. It is stuck between two places, unsure as to whether it duplicates observational data available to all, or whether it makes a contribution of its own, providing access to another kind of sight that is the special province of the artistic. Saint-Aubin's drawing mobilizes the fundamental tensions of the baroque understanding of representation, and, like that understanding itself, must ultimately leave these tensions in unresolved suspension.

1 "M. l'Eveque de Chartres n'avait jamais voulu consentir qu'on le peignit, m. le Comte de Maillebois me donne la facilité de faire ce portrait au travers d'un paravent, pendant qu'il dinoit avec ce prélat" (unless otherwise noted, all translations are by the author). For a general overview of Saint-Aubin's work, see Emile Dacier, *Gabriel de Saint-Aubin: Peintre, dessinateur et graveur (1724–1780)*, 2 vols. (Paris and Brussels: G. van Oest, 1931).

2 It is not known whether a more finished portrait ever actually issued from this joke. That the artist should refer to "this portrait" in describing this drawing is unusual, since it follows none of the conventions of baroque portraiture and seems more like a visual memoir of an especially amusing session of portraiture. Some of the difficulty may come from the fact that, according to The Art Institute of Chicago's records, the artist did not write the inscription; instead, his brother did. In any event, it seems highly unlikely that scholars will ever be able to sort out such matters over two hundred years after the fact, and they are not central to the present essay.

3 The principal sources I draw on for this necessarily brief discussion of Aristotle, genre theory, and their place in the baroque are: Larry F. Norman, *The Public Mirror: Molière and the Social Commerce of Depiction* (Chicago: University of Chicago Press, 1999); *Averroes' Middle Commentary on Aristotle's Poetics*, trans. Charles E. Butterworth (Princeton, N.J.: Princeton University Press, 1986); Pierre Pasquier, *La Mimèsis dans l'esthétique théâtrale du XVIIe siècle: Histoire d'une réflexion* (Paris: Klincksieck, 1995); and Emmanuel Bury, "Comédie et science des moeurs: Le Modèle de Terence aux XVIe and XVIIe siècles," *Littératures classiques* 27 (1996): 125–36.

4 He stakes out this position near the outset of the *Poetics*, in ch. 2. See *The Poetics of Aristotle*, trans. Stephen Halliwell (Chapel Hill: University of North Carolina Press, 1987).

5 For example, Averroes, in his twelfth-century commentary on Aristotelian aesthetics, dedicated almost no attention to the third mode of the *Poetics*, considering it as "like matter ready to be transformed into either of the two extremes [the first and second modes]"; *Averroes' Middle Commentary*, 67. Averroes took this position because of his emphasis on moral pedagogy, which demanded that one represent either virtues or vices, and that one do so fairly starkly. Aristotle's third mode contributes nothing to such a project, and so it received little elaboration in Averroes's highly influential work.

6 It should be noted that this perceived discrepancy was a novelty, and that the question of how the truth of types relates to the truth of individualities took a very different form prior to and after the baroque age. An artist who treats his model in reference to an interior typological idea is entitled to argue, from a certain perspective, that his depiction is far truer than that of an artist who only copies visual appearances, and many baroque artists did in fact take this position.

7 There is a wealth of material on this debate; see André Félibien, *Entretiens sur les vies et sur les ouvrages des plus excellens peintres anciens et modernes* (Paris: D. Mariette, 1696); *L'Idée du peintre parfait, pour servir de règle aux jugemens que l'on doit porter sur les ouvrages des peintres* (London: David Mortier, 1696); Roger de Piles, *Cours de peinture par principes* (Paris: Gallimard, 1989); and Jean Donneau de Visé, *Zélinde, comédie; ou la véritable critique de "L'Ecole des femmes," et la critique de la critique,*

in Georges Mongrédien, ed., *La Querelle de "L'Ecole des femmes,"* 2 vols. (Paris: Société des Textes Français Modernes, 1971), vol. 1, 1–83.

8 The discussion of Molière throughout this essay follows and proceeds from Norman.

9 Donneau de Visé, *Zélinde*, scene 6, in Mongrédien, ed., vol. 1, 37–38.

10 *Honnêteté* has received a fairly sustained treatment in the scholarly literature. Domna C. Stanton's *The Aristocrat as Art: A Study of the* Honnête Homme *and the* Dandy *in Seventeenth- and Nineteenth-Century French Literature* (New York: Columbia University Press, 1980) guides this discussion.

11 Edward A. Maser, catalogue entry in *The David and Alfred Smart Museum of Art: A Guide to the Collection*, ed. Sue Taylor and Richard A. Born (New York: Hudson Hills Press, 1990), 69.

12 This reading of Molière's relation to his audience comes from Norman, esp. ch. 6.

13 Donneau de Visé, quoted in Molière, *Oeuvres complètes*, ed. Georges Couton (Paris: Gallimard, Bibliothèque de la Pléiade, 1971), 1020.

14 Donneau de Visé, in Molière, 1019.

15 Pierre Nicole, *Essais de morale* (Paris, 1675), 3:16.

16 In this context, consider the dog in the drawing. Clearly, some species of parallelism obtains between the dog and the artist. The dog looks in the same direction as the artist, has his own tiny enclosure like the artist, and appears directly above the artist's signature. On the one hand, it seems legitimate to view the dog as a candid admission on the part of the artist that he too is just another of the count's creature, no different from any other courtier. On the other hand, the position of a dog at court is *so* marginal and precarious that one wonders if the dog's status as a total outsider might not present it—and, by analogy, the artist—with the chance for observations that would be unlike anyone else's.

17 For one example, see Emmanuel Coquery, "Le Portrait en tableau," in *Visages du Grand Siècle: Le Portrait français sous le règne de Louis XIV, 1660–1715* (Paris: Somogy Éditions d'Art, 1997), 131–34.

18 Coquery, 121 and 132.

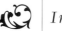

SETS FOR SOCIAL PERFORMANCE

BRANDY FLACK AND REBEKAH FLOHR

BAROQUE FRANCE SAW THE triumph of theatricality in all aspects of social life. Inherited from the Italian Renaissance and the sorts of practices outlined in Baldassare Castiglione's *Il Cortegiano*, the culture of manners and performance reached its highest pitch at the French courts of the mid-seventeenth through mid-eighteenth centuries. In this context—where an emerging leisured class relied above all on self-presentation to distinguish itself, and where a centralized monarchy promoted a highly codified, self-conscious mode of address—life itself became theater (see Norman, pp. 4–7). The measures individuals took to promote their place in society paralleled those used by actors to prepare a role for the stage. One's image, projected through manner of speech, dress, and embellishments of the home and other physical surroundings, was a critically important indicator of social worth. And although significant shifts in style characterize these material trappings during the broad period under consideration here, their basic function was constant: they were the props of social life, the ornaments used by the French elite to situate themselves in the intricate, often forbidding structure of court politics. Even as tastes shifted from what art historians generally term the baroque to what they call rococo,[1] this essential function—to define and display one's social position—

remained central to the decorative arts of the period.

The importance of material culture as a form of self-representation reached extraordinary heights under Louis XIV (1643–1715), who perfected this mode of expression and asserted his power by surrounding himself with objects that both illustrated and reinforced his *grandeur*. The Sun King's residence at Versailles is perhaps the most celebrated and luxurious setting of the period, and it demonstrates the inseparability of the arts from the political context within which they were produced. Here not just architecture, but also the fine and decorative arts, were highly theatrical demonstrations of Louis's political, economic, and social power. Indeed, the consolidation of power under the absolutist governments of seventeenth- and eighteenth-century France proved to be essential to the development of the decorative arts as a unified category. As historian Leora Auslander has remarked, "[o]bjects, especially domestic objects, played a distinctive role in the representation and maintenance of power under absolutism; the crown displayed its strength both through its possessions and through its control of those who made, sold, and bought them."[2]

Louis XIV used the alluring splendors of Versailles both to satisfy the social longings of the disenfranchised

nobility and to control the ambitions of the bourgeoisie. No longer able to assert authority based on military strength, the aristocracy "entered the court and thus direct dependence on the king. Only life at court opened to individual nobles within this social space access to economic opportunities and prestige that could in any way satisfy their claims to a demonstratively upper-class existence."[3] The bourgeoisie, too, were susceptible to seduction by the king, who granted elite positions, otherwise unattainable, to members of the middle class, thus securing their loyalty.

Success in this setting depended on being noticed by the king. In the court of Louis XIV, appearance and decorum were all-important. The popularity of theater at the time reflects the conditions of social life: the stage performances of the actors in Molière's troupe paralleled the everyday performances given by individuals seeking social recognition and promotion (see Ellenbogen, p. 27). The works of such writers and social observers as La Rochefoucauld, Madame Lafayette, and Molière document the pervasiveness and self-consciousness of social performance. Even in informal correspondence, the all-important element of theatricality is captured. In a letter to her daughter, Madame de Sévigné described the real-life performance of one Madame de Brissac:

Mme de Brissac had colic today. She was in bed, beautiful and bonneted in the most sumptuous fashion. I wish you could have seen what she made of her pains, and the use of her eyes, and the cries, and the arms, and the hands which trailed over her bed-clothes, and the poses, and the compassion which she wanted us to have. Overcome with tenderness and admiration, I admired this performance and I found it so beautiful that my close attentiveness must

have appeared like deep emotion which I think will be much appreciated.[4]

This intriguing passage portrays, as Nicholas Hammond has pointed out, a kind of double performance: that of Madame de Brissac, beautifully made up but at the same time exploiting her illness to move her audience, and that of Madame de Sévigné herself, whose appreciation of the performance will be perceived as deep sympathy for her hostess's condition.[5]

Adornment, costume, gestures, and other theatrical elements thus served individuals well as indicators of identity and status—real or desired. In this culture of display, however, objects could also define status and character. Because social life revolved around Versailles and the salons of nearby Paris, families spent more time and invested more money in their Parisian residences, accumulating ornamental objects that complemented the massive beds, upholstered chairs, and coordinated wall hangings that were the fashion. The earliest example of the coordinated seventeenth-century interior is the pioneering salon of the Marquise de Rambouillet. During the 1620s and 1630s, her *hôtel*, or private residence, served as a meeting place for the members of the *bonne société* of Paris, from nobles to promising writers and poets. The marquise played an integral role in all stages of the design of her residence. She may have supplied some of the architectural drawings, and she introduced the use of a color scheme to create an atmosphere of comfort and harmony for her guests. In residences such as the Hôtel de Rambouillet, the décor of each room was unified—the marquise was particularly famous for the *régularité* of her home's interior spaces.[6] In addition to this sort of self-conscious design, elaborate display became increasingly impor-

tant through the late seventeenth and eighteenth centuries; ornate furnishings and table settings made evident the luxury of one's lifestyle. Like props, decorative objects were used to illustrate the grandeur of those who owned them.

As more and more resources were poured into the arts during the reign of Louis XIV's successors, tastes became increasingly extravagant.[7] This tendency is evident not only in the growing number of decorative objects that filled the homes of the wealthy, but also in the form these objects took. The Smart Museum's Chantilly bowl and platter is a excellent example of this design trend [COLOR PLATE 5]. The simplicity of its stark, white surface offsets wavy outlines and swirling ornamental details. Asymmetry, dynamism, and even a certain monumentality—one that belies the natural fragility of porcelain—make this bowl a genuinely theatrical object, the sort of piece featured in elaborate table settings.[8] Table decoration was an important art during the seventeenth and eighteenth centuries, and included ornate works not only of porcelain, but of glass, silver, and even sugar-paste.[9] Categories of tableware expanded during this period to include increasingly specialized utensils for serving and eating. This trend paralleled the evolving attention to table manners, a highly codified set of ritual behaviors by which the French elite sought to distinguish itself.[10] If the diners at the banquet were the actors, objects like the Chantilly bowl were important props in the staging of social life [SEE FIGURE 12].

The decorative arts played a central role in the highly theatrical society of seventeenth- and eighteenth-century France. As signifiers of wealth and importance, as well as tools of persuasion, *objets d'art* ascribed merit and value to the people who owned them, whether or not they truly possessed these qualities. Just as actors combined mannerisms, costumes, and props to seduce an audience, socially ambitious individuals—aristocrat and bourgeois alike—employed carefully crafted speech, dress, and decorative objects to convince their peers of their status and social worth.

1 On the origins of the rococo and its relationship to the baroque, particularly with regard to interior design and the decorative arts, see Fiske Kimball, *The Creation of the Rococo* (New York: W. W. Norton & Company, Inc., 1964; 1st ed., Philadelphia: Philadelphia Museum of Art, 1942).

2 Leora Auslander, *Taste and Power: Furnishing Modern France* (Berkeley: University of California Press, 1996), 29.

3 Norbert Elias, *The Civilizing Process*, trans. Edmund Jephcott (Cambridge, Mass., and Oxford: Blackwell, 1994), 472.

4 Translation by Nicholas Hammond in *Creative Tensions: An Introduction to Seventeenth-Century French Literature* (London: Duckworth, 1997), 115; see letter dated May 21, 1676 in *Lettres nouvelles de Madame la Marquise de Sévigné à Madame la Comtesse de Grignan, sa fille* (Paris: Rollin, 1754).

5 Hammond, 115.

6 Peter Thornton, *Seventeenth-Century Interior Decoration in England, France, and Holland* (New Haven, Conn.: Yale University Press, 1978), 7–10.

7 On developments in interior decor, see Katie Scott, *The Rococo Interior: Decoration and Social Spaces in Early Eighteenth-Century Paris* (New Haven, Conn.: Yale University Press, 1995).

8 Louise Bross, catalogue entry in *The David and Alfred Smart Museum of Art: A Guide to the Collection*, ed. Sue Taylor and Richard A. Born (New York: Hudson Hills Press, 1990), 58.

9 Thornton, 286.

10 Increasing differentiation and refinement are two of the hallmarks of the "civilizing process" of the seventeenth and eighteenth centuries, as described in detail by Elias.

THE THEATER OF THE WORLD
Staging Baroque Hierarchies

ANITA M. HAGERMAN-YOUNG AND KERRY WILKS

> The purpose of playing . . . both at the first and now, was and is,
> to hold as't were the mirror up to nature.
> —SHAKESPEARE, *Hamlet*, act 3, scene 2, lines 20–22[1]

HAMLET'S ADVICE TO THE PLAYERS offers a philosophy of the theater that was widespread throughout the baroque period, that of art mirroring nature. This philosophy was equally applied by playwrights and visual artists of the time—not surprising, since theater and painting had long been considered sister arts.[2] But what is the "nature" the baroque artist and dramatist were to mirror? Renaissance scholars had inherited a clear perception of a hierarchical universe from the Middle Ages. According to this view, the world was a perfectly ordered structure, in which God reigns from heaven above, man exists on the earth below, and hell is an underworld lower still. The hierarchical structures of earthly institutions—led by divinely ordained representatives in both the political and religious spheres—mirror this larger, eternal order.[3] In the seventeenth and eighteenth centuries, this vision was "upset . . . by the growing force of empirical science and the weakening of the metaphysical view of the world."[4] Catholic theology—which placed man (earth) at the center of God's universe—was challenged not only by science but also by the Reformation.[5] In response to these tensions, the Church codified its doctrine at the Council of Trent (1545–63), leading to the establishment of the Counter-Reformation movement. This continuing theological controversy was a manifestation of a general need to restore a sense of harmony and order to the world. Baroque artists operated within this context, creating dynamic works that superimpose this unique tension upon the traditional representation of hierarchies, both earthly and heavenly.[6]

The metaphor of *theatrum mundi*,[7] or the world as stage, while not a new concept, was frequently employed by baroque thinkers to express an ordered world and the forces that threatened it. Both the theater and the visual arts of the period display a high degree of self-consciousness and self-referentiality, in which the expressive medium—in particular the space of stage and canvas—responds to and reinforces narratives that have strong hierarchical themes. An interest in hierarchies, in other words, connected the form and subject of baroque representations to a larger world view.

Throughout Europe, playwrights such as Molière and Shakespeare utilized the topos of *theatrum mundi* in their works to emphasize the close relationship between

the stage and life. A pictorial example in this exhibition is Gabriel-Jacques de Saint-Aubin's drawing *Gabriel de Saint-Aubin Executing the Portrait of the Bishop of Chartres* [FIGURE 12]. As seen in Josh Ellenbogen's discussion of this work, Saint-Aubin offered a theatrical metaphor for social life. Not only did the stage mirror "life," but life itself was represented as a social performance.[8] Nowhere was this metaphor more pronounced than in Spanish playwright Pedro Calderón de la Barca's 1635 work *El gran teatro del mundo* (*The Great Theater of the World*).[9] In this play, Calderón proposed that (to quote Shakespeare) "all the world's a stage," with God as the ultimate director. As the play opens, the *Autor*, both director of the play and a characterization of God, uses multiple metaphors to connect the creation of a play to the creation of the world. As actors arrive for their assignments, the Director/Creator gives each one a role that corresponds to a social category (i.e. Beggar, Peasant, King, Rich Man). As the play progresses, the actors must relinquish their earthly roles and pass into the eternal realm. Actors/souls are only allowed into God's presence if they have proven their worth in their roles/lives. Calderón not only reinforced the existence of a temporal or earthly hierarchical order, but he also stressed the ultimate supremacy of the eternal hierarchy found in God's kingdom. There is an illusory quality to the earthly hierarchy, as each man's assigned role in this world is only a shadow of the more permanent part to come.

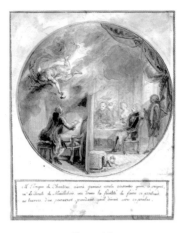

Figure 12

This idea was presented on various stages throughout Europe. A particularly striking French example is Jean de Rotrou's *Le Véritable Saint Genest*, in which an actor playing the role of a martyr merges with this role when he is killed for converting to Christianity during the staging of the play. Shakespeare employed it (with temporal rather than theological focus) in works such as *Hamlet*, *Macbeth*, and most famously, *As You Like It*:

> All the world's a stage,
> And all the men and women merely players.
> They have their exits and their entrances;
> And one man in his time plays many parts,
> His acts being seven ages.
>
> —act 2, scene 7, lines 138–42

Seeing an opportunity to reinforce the precepts of the Counter-Reformation, Catholic artists frequently represented the triumph of divine order in the world, employing a well-developed vocabulary of visual devices to do so. These are best seen in Pierre Daret de Cazeneuve's engraved title page (after a painting by Jacques Stella) to the *Conciliorum omnium generalium et provincialium, collectio regia* [FIGURE 17], a thirty-seven-volume work that describes the proceedings of various councils of the Church (both ecumenical and provincial) from 34 to 1623 C.E. This engraving is an allegorical rendering of the Church's struggle against its enemies: a woman, symbolizing Faith or Divine Wisdom, defends herself from the figures—probably emblems of Heresy—who attack her. The power of the Holy Spirit, reflected off a brandished shield, allows her to repel these forces. A fragmentary view of a statue of Saint Peter, whose keys to the gates of heaven point directly down at the papal tiara, signals the source of the pope's authority and the channels of divinely controlled hierarchy.

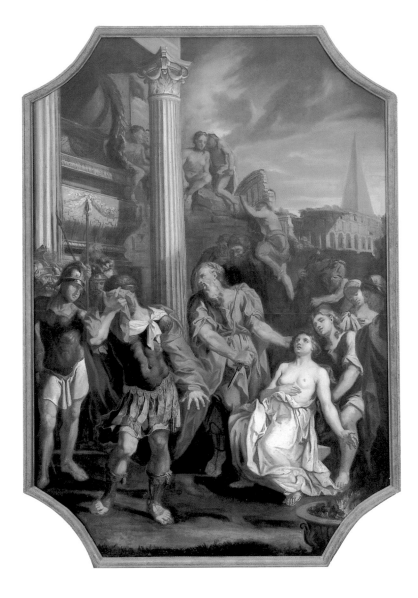

Figure 19
Artist Unknown (formerly Gérard de
Lairesse), *The Sacrifice of Polyxena*,
late 17th or 18th century
(Cat. No. 22)

This visualization of divine order is further elaborated in Francesco Fontebasso's *Martyrdom of Saint Catherine* [FIGURE 18/COLOR PLATE 6] and in the *The Sacrifice of Polyxena* by an unknown artist [FIGURE 19].[10] While Daret de Cazeneuve presented an explicit vision of God's eternal order in the world, Fontebasso and the painter of the *The Sacrifice of Polyxena* played with the boundaries between temporal and eternal hierarchies. These representations of martyrdom show the moment of rupture when order becomes disorder. Paradoxically, temporal chaos accentuates the order that will ultimately be restored when the victim claims her natural spot in God's eternal hierarchy. In the image of Polyxena, witnesses react to a violent event that should not occur in a justly ordered world: one covers his eyes, unable to watch the sacrifice; even the horse shies away. Stormy skies and crumbling ruins in the background reinforce the tumultuous mood. Fontebasso portrayed not only the chaos of the moment of martyrdom, but also a suggestion of the saint's subsequent salvation. Catherine's gaze guides our eyes to the space above, where an opening in the clouds reveals a glimpse of heaven, with angels waiting to receive the soul of the new saint. Thus, while both works depict the chaos within the temporal order, Fontebasso's

image is more explicit in stressing the underlying order that will ultimately be restored to it through the eternal hierarchy and the exemplum of martyrdom.

Composition, as well as content, is crucial in baroque depictions of hierarchy and *theatrum mundi*. The spatial arrangement of stage or canvas could demonstrate a naturally ordered universe through the manipulation of vertical and horizontal positioning. In response to new imperatives, theatrical space evolved from the bare medieval stage to an elaborate Italianate one, characterized by machinery, large sets, and spectacle.[11] Playwrights across Europe utilized a vertical visual hierarchy to experiment with and express the topos of *theatrum mundi*: stage architecture, reflecting the architecture of the world, placed the heavens above and the underworld below. The highest spaces (balconies, platforms, the increasingly important "flying" machinery) denoted the province of kings, gods, and other lofty characters. For example, in *The Tempest*'s wedding masque, the goddesses most likely appeared on the balcony while the sub-human Caliban inhabited the hellish world of the understage space, accessible through trapdoors.[12] A similar vertical hierarchy is evident in many of the works in this exhibition. For example, in the title page by Pierre Daret de Cazeneuve, chains of command clearly flow from the top to the bottom of the work. The literal and figurative "highest" level contains both the statue of Saint Peter and the dove that represents the Holy Spirit. In the earthly realm directly below, the papal tiara represents the temporal version of Saint Peter's eternal ecclesiastical power. Faith pushes her enemies not only out of the frame of the picture, but also downward, toward hell. The lowest figure in the work, in fact, is a vanquished foe who has fallen to the ground and whose body disappears into darkness—all we can see of him is his left leg.

Adriano Manglard's *Design for the Cupola of Sant'Agnese, Rome* (after a work by Ciro Ferri) [FIGURE 7] exemplifies the baroque use of vertical hierarchy. This piece depicts only the heavenly realm, populated with saints and angels. The implied earthly realm is the space of the church itself, occupied by worshipers who look on from below. While most Renaissance ceiling decorations are firmly and evidently contained by their architectural frames, baroque artists often painted the architecture away for the viewer. The physical ceiling disappears as we are presented with an illusion of a heavenly scene (see Huddleston, p. 14).[13]

While verticality may seem to be a natural means of expressing hierarchy, the horizontal axis can also establish an ordered structure. Calderón's *El gran teatro del mundo* exemplifies extreme horizontality on a baroque stage. The play has its origins in medieval *autos sacramentales*, religious dramas performed by traveling troupes around two carts. In the sixteenth century, Spanish drama had moved into *corrales*, open-air theaters similar in design to Shakespeare's Globe Theatre. Religious drama followed suit, as playwrights took advantage of the new stage space. Calderón's *autos* (which completely dominated the genre in Madrid for over three decades) featured stylized carts placed on the stage itself. The result was a space that encouraged playwrights to compare, left against right, two places or events. In *El gran teatro del mundo*, the two carts represent the earthly and heavenly reigns, creating a literal, theocentric *theatrum mundi*. Fontebasso's painting *The Martyrdom of Saint Catherine* also emphasizes a horizontal juxtaposition. The emperor, at the right, theatrically stretches his arm to guide the viewer's gaze horizontally across the painting to Catherine's impending execution. At that point the vertical axis comes into play, as

Figure 7

light from above bathes the central figure. Catherine, at the moment of her martyr-
dom, thus represents the conjunction of the horizontal and vertical hierarchies and
encourages a comparison between the earthly and divine orders.

Fontebasso created a frame for this scene by arranging various figures around his
heroine, Catherine, who occupies the middle ground. In a similar vein, discovery
spaces that opened off the rear wall of the baroque stage could be used to disclose
important events or characters, even though they were located farther away from the
audience. For example, at the end of *The Tempest*, Prospero reveals the blissfully united
Ferdinand and Miranda in the discovery space. Discovery spaces remind us that the
baroque stage was open and expansive: dialogue was spoken from offstage, characters
could enter or exit through trapdoors or from trapezes, and the discovery space added
depth and dimension to the main stage area. In France where, in accordance with the
rules of decorum, violent acts could not be shown on stage, the offstage space was
particularly important. Pivotal events would be reported to the audience via a messen-
ger character. Visually, the doorway in Laurent de La Hyre's *Panthea, Cyrus, and
Araspus* [FIGURE 5] functions precisely as a discovery space, by opening up the back
wall and revealing a large massed army to the painting's audience. As Larry F. Norman's
introduction suggests, both baroque painting and staging created tight dramatic spaces
that opened up to accommodate sophisticated narrative structures; in the story pre-
sented by de La Hyre, the fate of the armies in the distance will largely determine the
fortunes of the characters who occupy the foreground.

Figure 5

Baroque artists frequently extended the represented space of stage or canvas to
include the viewer or audience. For example, both Fontebasso and the painter of *The
Sacrifice of Polyxena* emphasized the theatricality of the martyrdom by alluding to
two groups of spectators. As viewers of the images, we are one group; those watching
the executions within the works themselves are another.[14] Since the executions are
"performed" in a public space, the spectators can be described as an audience that has
come to watch the theater of death—the executioner's block is converted into a stage.
(This play-within-the-painting has obvious parallels with the play-within-a-play trope
favored in baroque drama.)

The Blessed Virgin in Glory, a print by Pietro Aquila after a work by Carlo
Maratta [FIGURE 21], also layers spectators in a theatrical tradition. The Virgin is
surrounded by an "audience" of angels and saints, creating the sensation of theater-
in-the-round. The work's dynamic, complicated composition may instructively be
compared with a typical mid-sixteenth-century image such as *The Assumption of the
Virgin* attributed to Paolo Veronese [FIGURE 20] to demonstrate the stylistic evolu-
tion of the baroque. In contrast to Veronese's neat, easily legible division of the canvas
into heavenly and earthly realms, Aquila's print offers a swirling, even dizzying array
of figures, which draw us in with their forceful momentum. Similarly, sculptor
Francesco Bertos achieved the dramatic intensity of theater-in-the-round with his
Marcus Curtius [FIGURE 22], a composition based on a famous Roman relief but
transformed here into a work inviting multiple points of view.[15] This is an expansive
piece, infused with twisting movement and energy. With centrifugal force, the horse's
legs and the figures' gestures seem to break into the viewer's space. Jacques Callot's print
of a staged joust from his *Combat at the Barrier* series [FIGURE 23] also reminds us
of the importance of audience placement within the theatrical tradition. In court or

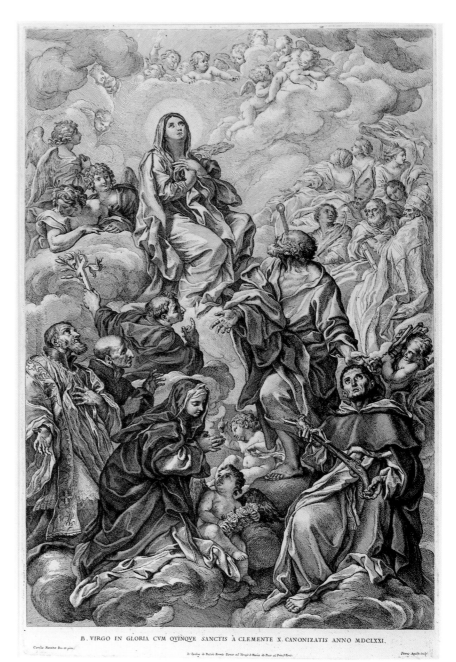

B. VIRGO IN GLORIA CVM QVINQVE SANCTIS À CLEMENTE X. CANONIZATIS ANNO MDCLXXI.

Figure 20
(above)
Attributed to Paolo Veronese,
The Assumption of the Virgin,
oil on canvas, 1548. Chicago, The David
and Alfred Smart Museum of Art, Gift of
the Samuel H. Kress Foundation,
1973.38 (Not in exhibition)

Figure 21
(right)
Pietro Aquila (after Carlo Maratta),
The Blessed Virgin in Glory, 1671
(Cat. No. 21)

Figure 22
Francesco Bertos, *Marcus Curtius*,
circa 1690–1710
(Cat. No. 24)

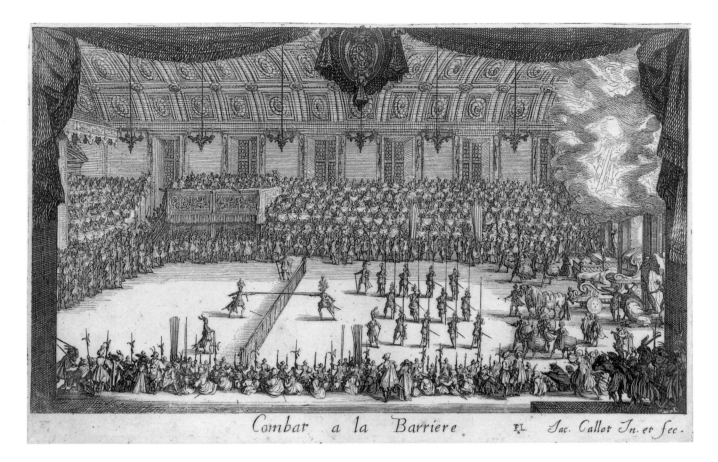

Combat a la Barriere ɪ Jac. Callot In. et fec.

Figure 23
Jacques Callot,
Combat at the Barrier,
1627 (Cat. No. 4)

palace productions, as this print indicates, audience space often merged with the physical stage. Public theaters were similarly structured, with audience members' chairs often placed on the stage itself. The result was a blurring of the boundaries between spectator and performer, between the life of the stage and that of the larger world.

For the baroque artist, the world truly *was* a stage, reflecting the ever-present tensions of a changing world. Counter-Reformation theologians, challenged by new religious and scientific theories, strove to reestablish traditional perceptions of an ordered world. These ongoing controversies shaped the baroque view of the universe, paradoxically typified by both tension and order. Baroque artists and playwrights rose to the occasion with boundless energy and explosive creativity, questioning and redefining the relationship between art and life.

1 All quotations from Shakespeare in this essay are from *The Complete Works of William Shakespeare*, ed. David Bevington, updated 4th ed. (New York: Longman, 1997).

2 Rensselaer W. Lee offers valuable insight on the relationship between painting and drama in his book *Ut Pictura Poesis: The Humanistic Theory of Painting* (New York: W. W. Norton & Company, 1967).

3 While debate remains regarding how widely accepted this highly structured view of the universe actually was, scholars generally agree that both the Church and the powerful monarchies of the day wished to promote it. For further dis-

cussion, see Jeffrey Denton, *Orders and Hierarchies in Late Medieval and Renaissance Europe* (Toronto: University of Toronto Press, 2000), and E. M. W. Tillyard, *The Elizabethan World Picture* (New York: Random House, 1946).

4 John Rupert Martin, *Baroque* (New York: Harper & Row, 1977), 12.

5 The Copernican revolution—which encompassed the work of four astronomers, Nicolaus Copernicus, Tycho Brahe, Johannes Kepler, and Galileo Galilei—introduced radically new conceptions of the universe. While Copernicus stunned the world with his theory of a heliocentric yet finite universe, Giordano Bruno's later

proposal of an infinite universe seemed even more revolutionary. A detailed account of the manifestations of this scientific impact can be found in Isabel Rivers, *Classical and Christian Ideas in English Renaissance Poetry*, 2nd ed. (London: Routledge, 1994). For the relationship of this revolution to the treatment of space in the visual arts, see the essay in this catalogue by Robert S. Huddleston, pp. 13–19.

6 For a detailed discussion of the evolving crisis in representation from the Renaissance to the baroque era, see Michel Foucault, *Les mots et les choses* (Paris: Gallimard, 1977).

7 *Theatrum mundi* derives from classical sources such as Plato and Horace and from Early Christian writers such as Paul (see 1 Cor. 49:9). Ernst Robert Curtius thoroughly traces the origins of *theatrum mundi* in *European Literature and the Latin Middle Ages*, trans. Willard R. Trask (New York: Pantheon, 1953), 138–44.

8 For a discussion of theater as a metaphor for aristocratic life, see Domna C. Stanton, *The Aristocrat as Art: A Study of the* Honnête Homme *and the* Dandy *in Seventeenth- and Nineteenth-Century French Literature* (New York: Columbia University Press, 1980). For a period-specific discussion of the theatricality of aristocratic life, see Baldassare Castiglione's 1528 treatise *The Book of the Courtier*, trans. George Bull (New York: Penguin, 1967).

9 Pedro Calderón de la Barca, *El gran teatro del mundo*, ed. Anthony Zahareas and Barbara Kaminar de Mujica (New York and London: Oxford University Press, 1975). According to Ernst Robert Curtius, the Spanish interpretation of *theatrum mundi* is unique in terms of its theocentric concept of human life. By placing God at the center of *theatrum mundi*, Spanish dramatists asserted the superiority of the eternal hierarchy to the temporal existence, a position that was central to Counter-Reformation theology.

10 Although formerly attributed to Gérard de Lairesse, the *Sacrifice of Polyxena* is not given to the artist by Alain Roy. Roy does note that the painting was attributed to the French painter at least as early as 1818. He also observes that heavy overpainting makes a firm attribution extremely difficult. The close relationship between the painting and a 1667 engraving by de Lairesse further complicates the attribution.

See Roy, *Gérard de Lairesse, 1640–1711* (Paris: Arthena, 1992), 495–96 and 416–17.

The subject of this painting is also problematic. Its protagonist has most recently been identified as Polyxena, but has also been called Iphigenia, the daughter of Agamemnon sacrificed by her father during the Trojan War (Smart Museum archives). In baroque iconography, classical figures were often endowed with Christian meaning and used to represent aspects of Christian theology; see Martin, ch. 8, "Attitudes to Antiquity."

11 Stage horizontality was also important to French and English sets, which commonly depicted two mansions on either side of a street, highlighting a left-right division of the main stage space. For a good general discussion of the variety of theater spaces in the baroque era, see Oscar G. Brockett, *History of the Theatre*, 8th ed. (Boston: Allyn and Bacon, 1999); and W. B. Worthen, *The Harcourt Brace Anthology of Drama*, 2nd ed. (New York: Harcourt Brace College Publishers, 1996).

12 In David Bevington's words: "With painted heavens above and trapdoor (or doors) leading to the underworld below, the main stage could suggest the earth itself, the realm of human activity, set in the midst of a cosmic *theatrum mundi*"; *Action is Eloquence: Shakespeare's Language of Gesture* (Cambridge, Mass.: Harvard University Press, 1984), 99. This work contains an in-depth discussion and analysis of the use of space to reflect hierarchical issues in Shakespeare's plays.

13 On the Renaissance precedents to this illusionistic device—most importantly the work of Correggio—see John Shearman, "Domes," ch. 4 in *Only Connect . . . Art and the Spectator in the Italian Renaissance*, Bollingen Series 35 (Princeton, N.J.: Princeton University Press, 1992), 149–91.

14 For a study of painting's theatrical relation to the spectator in the mid-eighteenth century, see Michael Fried, *Absorption and Theatricality: Painting and Beholder in the Age of Diderot* (Chicago: University of Chicago Press, 1980).

15 Mario Pereira and Ingrid D. Rowland, catalogue entry in *The Place of the Antique in Early Modern Europe*, ed. I. D. Rowland (Chicago: The David and Alfred Smart Museum of Art, 1999), 66–67.

 Interlude

STAGING THE GAZE

DELPHINE ZURFLUH

IN THE SEVENTEENTH CENTURY, theater and painting were in continuous dialogue; the identity of each medium depended on the other. Of course, there is nothing radically new about this dialogue: the theory of the relationship between theater and painting dates to antiquity. In his *Poetics*, Aristotle contended that, "just as colour and form are used as means by some, who . . . imitate and portray many things by their aid, and the voice is used by others; so also in the above-mentioned group of arts [the dramatic arts], the means with them as a whole are rhythm, language and harmony."[1] The heritage of this venerable dialogue between the sister arts, most famously expressed in Horace's formula *ut pictura poesis* (as in painting, so in poetry), however, was infused with new vitality and dynamism in the baroque age, as aestheticians extended Aristotle's and Horace's principles to the narrative aspects of painting. In particular, artists, playwrights, and theoreticians applied the dramatic notions of audience identification and emotional response (catharsis) to the visual arts. Figures in a painting, according to this line of thought, should, like characters in a play, display some human flaws to enable viewers to identify with them. And the artist or writer should strive for something more powerful than simple familiarity or recognizability; when tragic themes are represented, for example, the viewer should experience intense emotions of pity and fear.

Painters who aspired to meet Aristotelian requirements thus devised a variety of compositional means, first to capture the viewer's attention and then to convey often complex narratives. The painter's choice of subject had to be appropriate and legible in order to move the viewer, a requirement that often necessitated departures from strict realism. Like a stage setting, the mixture of architectural elements in the Smart Museum's *Sacrifice of Polyxena* [FIGURE 19] was meant to suggest rather than document the past, in this case the ancient city where Polyxena was martyred. Soldiers' uniforms identify the villains, while the victim and her supporters wear graceful, flowing robes. Although setting and costume give the viewer a certain amount of factual information, the precise action and moral message reside in the interactions among characters—interactions represented by means of gazes exchanged or denied.

Reading the gazes between the figures forces the viewer to be aware of his or her own visual activity, thus highlighting the nature of representation as an active experience. Art historian Ernst Gombrich's concept of "the beholder's share" is useful in this context. Gombrich maintained that "the mind of the

beholder also has its share in the imitation."[2] Indeed, the beholder projects his or her knowledge on a painting and, in the process of looking at it, interprets it. The work allotted to the beholder allowed baroque artists to suggest that which could not, according to the pervading rules of decorum, be explicitly painted. The difficulties artists faced in representing violence exemplify this challenge. Neo-Aristotelian aesthetics prohibited showing violent action on stage, a precept elaborated by late Italian Renaissance theoreticians and most rigidly enforced in France (though largely ignored elsewhere, particularly in Jacobean England). Although the French Académie strongly discouraged representations of violence, a painter could manipulate the narrative to allude to the unrepresentable, just as a playwright might refer to action taking place offstage. A number of images in the present exhibition attest to this approach to violent subjects. Laurent de La Hyre's *Panthea, Cyrus, and Araspus* [FIGURE 5], for example, deals with rape; *The Sacrifice of Polyxena* [FIGURE 19] and *Actaeon Surprising Diana and Her Nymphs* after Francesco Albani [FIGURE 30] deal with martyrdom and murder. But for decorum's sake, these violent events were not depicted; instead, in the tradition promoted by the Academy, the artist showed the moment that precedes or follows the brutal act. The beholder has to be active to decipher the message and read between the gazes, thereby imagining the pain experienced or witnessed by the figures.

In addition, viewers must look beyond the exchange of gazes and gestures to take in the whole context of the image and what might lie beyond it. This interpretive activity occurs at the moment of first glance, and deepens over more prolonged contemplation. As Jean Starobinski asserts in his essays on the gaze in French classical theater, "the gaze does not exhaust itself immediately."[3] He continues: "what interests me is the fate of the impatient energy that inhabits the gaze and desires something different other than what it is given. It lies in wait, hoping that . . . a figure at rest will reveal a slight tremor, insisting on touching the face behind the mask."[4] Starobinski does not restrict his study to tragic drama but applies it also to painting: "for writers and . . . for painters the adventure continues beyond the first view."[5] Thus, in works such as those featured here, the centrality of the gaze hints at what is going on behind the curtain and in the wings of the stage. Reflecting upon one another, baroque theater and painting made new demands on the viewer, but also offered new expressive worlds.

1 Aristotle, *Poetics*, 1447 a, in *The Basic Works of Aristotle* (New York: Random House, 1941).

2 Ernst Gombrich, *Art and Illusion* (Princeton, N.J.: Princeton University Press, 1956), 182.

3 Jean Starobinski, *The Living Eye* (Cambridge, Mass., and London: Harvard University Press, 1989), 3.

4 Starobinski, 3.

5 Starobinski, 6.

TIME AND THE BAROQUE WORLD

MATT HUNTER

IN 1582, A PROCLAMATION issued under the authority of Pope Gregory IX announced a change in the calendar. According to this new, Gregorian system, ten days were to be deleted from the month of October, thus bringing the Julian calendar in accord with the increasingly sophisticated astronomical knowledge of the day. Readily adopted throughout Catholic Europe and the Americas, this system insured that holidays such as Easter could be calendrically situated with much greater facility and accuracy.[1] Such reforms were received less enthusiastically in Protestant lands; indeed, it was not until the middle of the eighteenth century that Great Britain finally acquiesced to the changes in temporal organization prescribed by Rome in the sixteenth century! The cumbersome temporal discrepancies that such local affiliations must have produced, however, may be seen as symptomatic of the larger crises occupying intellectual and quotidian life through the sixteenth and seventeenth centuries. During this extended period, mercantile and cultural attention was increasingly directed toward the lands and peoples of the periphery, while the Church—the traditional center of European life—was rent with conflict. The result, scholars have long argued, was the fragmentation and decline of High Renaissance culture.[2]

Not until the generation of Heinrich Wölfflin in the early decades of the twentieth century did sympathetic assessments of the baroque's artistic production gain much currency. Confronted with an art characterized by sharp contrasts of light and dark, billowing, convulsive forms, and ephemeral environmental effects like that in the angelic cloudburst of Francesco Fontebasso's *Martyrdom of Saint Catherine* [FIGURE 18/COLOR PLATE 6], Wölfflin defended this aesthetic as particularly attuned to temporal possibilities. As opposed to the Renaissance penchant for the timeless or fixed, the baroque picture "takes on the semblance of a movement ceaselessly emanating, never ending. Whether the movement be leaping and vehement, or only a gentle flicker, it remains for the spectator inexhaustible."[3] In this essay, I want to examine how the arts of the baroque era responded to broader temporal crises. In what ways did the place and time of the spectator mentioned by Wölfflin come to be considered differently? Following a brief sketch of the technology of time in the baroque world, two images—one produced for Protestant England, the other in Catholic Italy—will be considered as a means of elucidating these questions.

The expansion of the world through the voyages of Columbus and his successors produced a huge volume of information and many new mercantile opportunites. Although fifteenth-century European accounts had given verbal descriptions of New World flora and fauna, visual depictions of American species did not appear until the

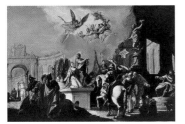

Figure 18

48

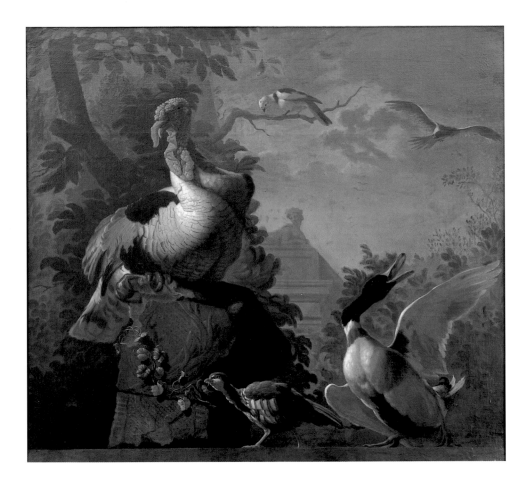

Figure 24
Philipp Ferdinand de Hamilton (?),
Wild Turkey, oil on canvas,
circa 1725–1750.
Chicago, The David and Alfred Smart
Museum of Art, Purchase, The
Cochrane-Woods Collection, 1982.77
(Not in exhibition)

mid-sixteenth century. Traces of this burgeoning interest may be identified in the much later image of a wild turkey [FIGURE 24]. Attributed to the Flemish artist Philipp Ferdinand de Hamilton, this picture is a startling representation of a uniquely American bird before a backdrop of Old World antiquities (including a sphinx lurking in the distance).[4] This conjunction of elements denotes an ongoing effort to reconcile older ways of understanding the world with the novelties brought to European markets by travelers to increasingly distant places. Such extended commercial voyages would not have been feasible without sophisticated time-reckoning devices. The absence of a reliable method of calculating longitude—and thus the ship's location far out at sea—had emerged as a serious problem by the mid-sixteenth century. With the hope of bringing expedient remedy to this pressing problem, King Philip III of Spain announced a competition in 1598 that would pay a handsome reward to anyone who could provide navigators with a reliable means of reckoning longitudinal locations. This inspired mariners, merchants, and mathematicians of many nationalities to seek a resolution to the perplexing conundrum.

Among those whose interest was piqued by the proposal was Galileo Galilei, the great Florentine astronomer. Galileo's earliest writings on the problem assert that the determination of terrestrial locations is inextricably bound with precise temporal calculation. Yet such exact temporal reckoning was a decidedly elusive prospect. Throughout the Middle Ages, time had been marked by the tolling of bells in local churches.[5] These bells indicated not only the time at which devotional acts took place, but also the opening and closing of the market and the city gates, and the hour of cur-

few. Clocks had proliferated exponentially since the fourteenth century, but their accuracy left something to be desired for the scientist; most were likely to lose at least one minute per hour. Such instruments were unsuitable for astronomical study and so, inspired by observations made in his youth of the regular swinging motion of a hanging lamp, Galileo proposed attaching a pendulum to a clock. While the successful implementation of the pendulum as a regulator of clockworks would only occur in the decades after the astronomer's death, Galileo's assertions about the necessity and means of precise temporal calculation found increasing sympathy in the world of the seventeenth century.[6]

A stark contrast to this scientific, mercantile time is offered by the grisly frontispiece to the 1639 English edition of *La Miroir qui ne flatte point* by the French baroque literary stylist Jean-Puget de La Serre [FIGURE 25].[7] Contemporaneous with Galileo's inquiries, this image suggests the persistence and force of earlier, medieval conventions in the depiction of time. Seated upon a throne of skulls, a gruesome skeleton appears adorned with the vestments of a monarch, holding a scepter in his right hand and resting his left foot on a globe. An hourglass complemented by a skull stands in the foreground at his left foot. As worms wriggle through the figure's ribs and eye sockets, he presents a mirror on which the volume's title is inscribed. The translated text's date and prefatory address link it to the English court of Charles I.[8] It is within this historical framework that an inquiry into the hourglass, the skeleton, and the mirror can shed light on our concerns. De La Serre's text participates in the then-resurgent genre of *ars moriendi*, or the art of dying well, a type of literature that mobilized shocking imagery to remind the audience of the transience of this world.[9] "The Air which corrupts continually," de La Serre asks, "is it not an image of our corruption? and without a doubt the Water's transparent body, represents us the fragility of ours; and its liquid crystalline, always rolling away, makes us see in its gliding, our flitting nature."[10] Although the human condition is thus mirrored in the world, vanity—the conviction that earthly pleasures are substantial—prevents us from seeing this. To correct this deception, one must "pry into oneself, in the Mirrour of his own ashes. . . . A mirrour, whose kind of shadow and *Chimera* makes us see in effect, that which we are in appearance."[11] De La Serre's aim was to prompt his readers' awareness that they faced annihilation following the expiration of their allotted increment of time.

If the mirror participates in this literary genre, it may be seen to have a similar function in contemporaneous pictorial conventions. The mirror as a sign of vanity or human folly has a long tradition in the visual arts and, in northern painting of the seventeenth century, may be seen to intersect with the emergent genre of still life. The so-called *vanitas* images, writes Fabrice Faré, "proffer a specific message: by the denunciation of human vanity, they seek to bring temporality, finitude and the illusions of humans into view."[12] Objects such as bubbles, burning candles, wilted flowers, human skulls, timepieces, and other paraphenalia could testify to worldly transience. Both a symbol of vanity and a portal to redeeming self-recognition, the hand-held mirror was a rich but comparatively recent addition to still-life composition and northern European material culture alike. It was only at the end of the sixteenth century that the skilled mirror manufacturers of Venice began to be drawn north.[13]

As the de La Serre frontispiece demonstrates, this new technology could be incorporated into existing imagery of mortality and transience. Yet notions of mirroring

O that they were Wise, that they vnderstood This,
that they would Consider their latter End! *Deut: 32,29.*

———— MORS sola fatetur
Quantula sint hominum corpuscula. ————
Iuvenal:

Figure 25
Jean-Puget de La Serre,
Frontispiece from *The Mirrour
which Flatters Not*, 1639
(Cat. No. 29)

found simultaneous employment in very different depictions of the world and human time, as demonstrated by the work of Anthony Van Dyck, a Flemish artist who studied under Rubens. The portraits that Van Dyck painted of Charles I and his courtiers are majestic indeed. Frequently the artist emphasized the monarch's power and prestige through symbolic devices like sunlight. Such symbolism is obviously related to questions of time, as the sun's arrival and departure mark one of the most basic divisions of the human day. Representing the king as the sun, in other words, aligns him with time itself. Many of Van Dyck's portraits of courtiers include a sunflower bathed in light—a symbol of the relation of subject and monarch.[14] The monarch is the central, life-sustaining force around which his subjects revolve and is, by extension, the arbiter of temporality itself.[15] The mirror in the de La Serre frontispiece, however, refracts light from a different, more powerful sun. The "king" is shown not in radiant apotheosis; rather, the image makes clear that the monarch must cede both his place and his adornments to victorious death. The king is not a higher celestial being but is subject to the same vicissitudes as all worldly things.

Claims about the essential sameness of all humans regardless of worldly station find articulation throughout the theater and graphic images of the time. In *El gran teatro del mundo* (*The Great Theater of the World*) by the Spanish dramatist Pedro Calderón de la Barca, for example, human life is presented as a theatrical role plotted out by an omniscient director and enacted upon the stage of the world (see Hagerman-Young and Wilks, p. 37). When our roles come to an end, so goes the moralizing adjuration, we will stand to be judged on how we acted and not on the grandeur of the part we played. As a redeemed beggar says to the dismayed king at the play's conclusion, "What you were doesn't matter . . . all actors are the same in the dressing room."[16]

The earlier pictorial convention of the *danse macabre* shares this moralizing conception of temporality. As depicted in popular vignettes, the *danse macabre* features death (represented as a decomposing body or skeleton) visiting various humans in the course of daily life and announcing their imminent ends. Death is the choreographer who leads all figures in the dance, who "opens and closes the chain, and at his will draws all the dancers round after him in ever new convolutions of the dance, just as Death draws after him all living things, great or small, rich or poor."[17] In *danse macabre* imagery, Death is frequently presented as having appropriated the physical appearance of his subjects. For instance, in *The Dance of Death at Basel* (a later work made in this same tradition), a worm-ridden Death wears a broad-brimmed hat like that of the cardinal whom he is calling [FIGURE 26].[18] Similarly, the skeleton in the de La Serre frontispiece does more than mirror the state of the king in the world; it also emphasizes the arbitration of the king's temporal role by a force that exceeds his power. A similar figuration of time as an all-powerful arbiter appears in the anonymous eighteenth-century sculpture *Allegory of Truth, Honor, Prudence, Vice, and Posterity* [FIGURE 27/COLOR PLATE 7]. Here, a winged Father Time is hierarchically positioned at the apex of a cluster of Virtues, who triumph over a cowering embodiment of Vice. Previously identified as *Louis XV Protecting Religion and Truth from Falsehood*, this sculpture and the de La Serre frontispiece both position Time as an imposing figure with whom even kings must reckon. The ultimate lesson is that one should act virtuously, as the call to perform one's last dance may come—even to the king—at any moment.

Figure 26
Death and the Cardinal
from *The Dance of Death
at Basel* (Basel, 1852)
(Not in exhibition)

Figure 27
Artist Unknown, French, *Allegory of
Truth, Honor, Prudence, Vice,
and Posterity*, circa 1745–1775
(Cat. No. 31)
See Color Plate 7

What recent art historians have attempted to elaborate, however, is how the "inexhaustability" Wölfflin saw in baroque art emerged by moving away from many of these conceits.[19] If the characterization of time in the de La Serre frontispiece recalls the cautionary, moralizing tone so prevalent in the seventeenth century, a print from the early 1660s entitled *Apollo Leading the Four Seasons in a Dance* by the French landscape painter Claude Lorrain refers to distinctly different theatrical premises, which are more formal than moral [FIGURE 28]. Claude's image suggests a dance—but this is not a *danse macabre*. While de La Serre's skeleton sits upon a morbid throne of skulls, Claude's figures are depicted in a landscape of picturesque tranquility. An aged Father Time plays a harp as Apollo leads the Four Seasons in a dance. According to the inscription below the image, "Apollo is obeying Time, while Spring starts the dance."[20] Apollo and the Seasons proceed along a path that weaves its way into the foreground, but we can only speculate as to whether Time has progressed with them through the landscape or has awaited their arrival. Are the dancers pleased to encounter their old friend, or do they simply delight in the verdant bloom and noble ruins that surround them? In either case, the image commemorates an occasion in which all are glad to participate. The joyous exchange of glances between Fall and Winter, and the attention with which Time looks to Apollo, suggest that this dance is motivated not by compulsion alone but by choice. If Time is the inevitable destination, in other words, the route leading to it is beautiful, and to be celebrated rather than regarded as punishment.

Together, the classically inspired Seasons, Apollo, and the figure of Time speak of a delight in the Greco-Roman past. Equally, these personifications suggest the transience of any particular historical moment and underscore the unceasing, cyclical march of time. Closer inspection of the action within the picture reveals additional, more mundane levels of temporal order as well. In this harmonious landscape, allegorical and lived time co-exist. As the Seasons dance across the foreground, two of the goats in the near middle ground seem to turn their heads in recognition of the performance, while the figures in the background take remarkably little note of it. Another goat, at the right-hand border of the meadow, evidently realizes it is time to eat. Near the center of the composition, a child directs the attention of a woman not toward the dance, but to a point that lies before them—something that will organize their time as they move toward it. Two travelers contemplate a ruin, perhaps discussing its origins. Each group finds its own time in the landscape that accommodates them all. The action of the dance directed by Time is central—both compositionally and thematically—to the image, but reverberates in differentiated form throughout the image. The activities of each secondary group of characters, while motivated by particular concerns, are seamlessly incorporated into the world of the picture. The discrepancy of this presentation of time from that offered by the de La Serre frontispiece indicates certain shifts in aesthetic priorities, away from emblematic didacticism and toward naturalistic *vraisemblance*, or verisimilitude. The placement of ennobled embodiments of time within a landscape marked by mundane temporal engagements belies the connection of Claude's etching to emerging visual expectations.

As has been fruitfully discussed by recent literary scholars, *vraisemblance* emerged as a central concern in the fine and dramatic arts of the seventeenth century. In conjunction with a reinterpretation of Aristotle's *Poetics*, greater demands were

Apollo in atto di obedire al tempo. la Primauera a cominciare il ballo. Leslate non manca del suo calore. Lautunno colsuo licuore. Seguita. Linuerno tiene la sua staggione. Claudio Gilleé inuen. Fec. Roma 1662. conlicenza de super.

placed upon works to produce convincing unities of action, place, and time; in short, to offer a believable fictional world to the beholder. To have *vraisemblance*, it was expected that a character within this fictional world would act by noble inner necessities, not by accidental impulses. Consequently, the beholder assumed that the particularities of a work could be explained through generally shared precepts.[21] As the Abbé d'Aubignac wrote in his influential *La Pratique du théâtre* of 1657, this expectation placed special emphasis on the relation of an action to its context: "Above all, we say that there is no human action that is entirely self-contained, that is not substantiated by the other actions that precede it, accompany it, compose it, and, together, give it being."[22] The unity of the work of art lies in the hierarchical organization of the elements—the totality of the fiction—surrounding a particular moment and action. A wonderful example of this dramatic presentation is found in Noël Hallé's *Joseph Accused by Potiphar's Wife* [FIGURE 1/COLOR PLATE 1]. In this scene from the Old Testament, Joseph—enslaved in the house of an Egyptian courtier named Potiphar—is wrongly accused of adulterous advances toward his master's wife. Potiphar's surprised indignation registers in his wide-eyed, exclamatory gesture, which, like the descending shadow on the interior wall, points toward the accused. As Joseph glances down at the cloak that has been used to incriminate him, he places his hand on his heart, swearing to his virtuous conduct.[23] Even in the face of unjust persecution, Joseph remains true to his noble character.

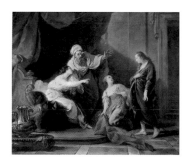

Figure 1

It is clear that both Hallé's painting, with its unified, internally driven narrative, and Claude's etching, with its diversity of incident, differ drastically from the de La Serre frontispiece. Rather than addressing the beholder self-consciously and purposefully, Hallé and Claude responded to growing demands that art be a world unto itself—a world motivated by its own discrete necessities yet commensurable with that of its viewers. Although Claude's figure of Time remains a personification of an abstract notion, he is a participant in action and his services are shown in various employments, dispersed throughout the populated landscape. This is not to say that the world of Claude's image remains independent of the particular arguments over place and time that preoccupied the seventeenth century. Indeed, this etching supports one final line of examination in light of the aesthetic of *vraisemblance*. If the foreground group of idealized figures provides the image's driving force and organizes the surrounding figures, what are we to make of the palm tree situated on the hillock in the right middle ground? Does such a species disrupt the unity of the otherwise deciduous woodland in which it stands? Not, it seems, if the viewers could connect it with the general character of the engraving. As Gérard Genette explains, "The *vraisemblable* narrative is one in which the actions respond, as much in application as in particulars, to a body of maxims received as true by the public to which it addresses itself."[24]

Traditionally, the palm was an emblem of victory for the Romans and one of rebirth for the Christians, a point of commensurability between pagan and Christian worlds. More specifically, it was associated with Christ's final entry into Jerusalem. The Gospel of Saint John offers a vivid description of this event:

> Next day, a great multitude of those who had come up for the feast, hearing that Jesus was coming into Jerusalem, took palm branches with them and went out to meet him, crying aloud, Hosanna, blessed is he who comes in the name of the Lord, blessed is the King of Israel.
> John 12:12–13

This day of entrance, known to Christians as Palm Sunday, anticipates the Passion cycle: "On Ash Wednesday, the first day of Lent, ashes placed on the forehead express the penitential nature of the season. The ashes are from the palms of the previous Palm Sunday."[25] The culmination of Lent is, of course, Easter—the calendrical focus of Gregorian reforms. This series of associations may help explain the presence of the palm in Claude's landscape: within the beholder's expectation of *vraisemblance*, the seemingly incongruous palm works to unify an earlier classical Time with the truth of Christian temporal reckoning.

Through a juxtaposition of the frontispiece of de La Serre's text and Claude's image, we may assess general shifts in the presentation of time in the baroque era. The frontispiece, freighted with medieval conventions, imparts a lesson concerning behavior and comportment. Time, the beholder is reminded, rules omnipotently and is thus given compositional and thematic centrality. Claude's image departs from this didacticism to present time as a component in human existence. Developed in conjunction with seventeenth-century theories of *vraisemblance* and temporal unity, this approach crystallizes time into a significant frame for worldly events. As Wölfflin suggested, and as the images considered here reveal, the struggle to give articulation to these differing notions of time was a central theme of baroque representation.

1 R. Poole, *Time's Alteration: Calendar Reform in Early Modern England* (London: UCL, 1998), 19–45; for the Americas, see *La Pragmática sobre los diez días del año . . .* (Santiago: Universidad de Chile, 1984), 27–29.

2 On this assessment, see Heinrich Wölfflin, *Renaissance and Baroque*, trans. Kathrin Simon (Ithaca, N.Y.: Cornell University Press, 1966), 15.

3 Heinrich Wölfflin, *Principles of Art History: The Problem of the Development of Style in Later Art*, trans. M. D. Hottinger (New York: Dover, 1950), 19.

4 Ingrid D. Rowland, catalogue entry in *The Place of the Antique in Early Modern Europe*, ed. I. D. Rowland (Chicago: The David and Alfred Smart Museum of Art, 1999), 95–96.

5 Gerhard Dohrn-van Rossum, *History of the Hour: Clocks and Modern Temporal Orders*, trans. T. Dunlap (Chicago: University of Chicago Press, 1996), 197–215.

6 Christian Huygens, a Dutchman whose work was reportedly independent of that of Galileo, is credited with fabricating the first clock regulated by a pendulum in 1657; Silvio Bedini, *The Pulse of Time: Galileo Galilei, the Determination of Longitude, and the Pendulum Clock* (Florence: Leo S. Olschki, 1991), 34.

7 De La Serre was attached to the court of Marie de Medici and his treatise on letter-writing (*Le Secretaire de la cour, ou Manière d'écrire selon le temps*) of 1623 appeared in numerous editions throughout the seventeenth century; Alain Viala, "Puget de La Serre," *Dictionnaire des littératures de la langue française*, ed. J.-P. de Beaumarchais et al. (Paris: Bordas, 1994), 1949.

 The engraver of the frontispiece to the English edition of de La Serre's work is unknown. The image is signed "I.P. SCULP," but this abbreviation of *sculpsit* had a range of meanings in early modern engraving; see Hanns Hammelmann, *Book Illustrators in Eighteenth-Century England*, ed. T. S. R. Boase (New Haven, Conn.: Yale University Press, 1975), 1–12.

8 While Charles achieved a substantial reputation as a patron of the arts, his political actions and Catholic sympathies raised the ire of many. The king's absolutist dismissal of Parliament in 1629 and the subsequent "Eleven Years' Tyranny" provoked the English Civil War in 1640; see M. Ashley, *England in the Seventeenth Century* (London: Hutchinson, 1978), 64–81.

9 David Cressy, *Birth, Marriage, and Death: Ritual, Religion, and the Life-Cycle in Tudor and Stuart England* (New York: Oxford University Press, 1997), 388.

10 Jean-Puget de La Serre, *The Mirrour which Flatters Not*, trans. T. Cary (London: R. Thrale, 1639), 6.

11 De La Serre, 12–13.

12 Fabrice Faré, "Les Vanités en France au XVIIème siècle et ses particularités," *Konsthistorisk Tidskrift* 65, 2 (1996): 104.

13 In late sixteenth-century England, for example, the only looking-glasses free of substantial distortion were those made of thick metal slabs. By the 1620s, however, Italianate skills had been thoroughly disseminated throughout London and the importation of looking-glasses had been forbidden to protect local craftsmen from foreign competition; Geoffrey Wills, *English Looking-glasses: A Study of the Glass, Frames and Makers (1670–1820)* (London: Country Life Limited, 1965), 41–42.

14 See Christopher Brown, *Van Dyck* (Ithaca, N.Y.: Cornell University Press, 1982), 147.

15 Although this solar symbolism and its implication (i.e. that the courtier's day should be ordered around the monarch in very ritualized and concrete ways) would be brought to fullest fruition at Versailles, they may be seen in nascent form here.

16 Pedro Calderón de la Barca, *The Great Theater of the World*, trans. and adapt. A. Mitchell (Woodstock, Ill.: Dramatic Publishing, 1990), 52.

17 Frances Rust, *Dance in Society: An Analysis of the Relationship between the Social Dance and Society in England from the Middle Ages to the Present Day* (London: Routledge & Kegan Paul, 1969), 26.

18 C. F. Beck, ed., *Todtentanz der Stadt Basel* (Basel: Verlag von C. F. Beck, 1852), no. 17.

19 For such arguments, see Michael Fried, *Absorption and Theatricality: Painting and Beholder in the Age of Diderot* (Chicago: University of Chicago Press, 1980).

20 The complete inscription reads: "Apollo in atto di obedire al tempo, la Primavera a cominciare il ballo. L'estate non manca del suo calore. L'autunno col suo licuore seguita. L'inverno tiene la sua staggione" (unless otherwise noted, all translations are by the author).

21 Gérard Genette, "Vraisemblance et Motivation," *Communications* 11 (1968): 7.

22 Abbé d'Aubignac, *La Pratique du théâtre* (Algiers: Jules Carbonel, 1927), 87.

23 For further discussion of this image, see Nicole Willk-Brocard, *Une dynastie: Les Hallé: Daniel (1614–1675), Claude-Guy (1652–1736), Noël (1711–1781)* (Paris: Arthena, 1995), 362–64.

24 Genette, 8. H. Diane Russell suggests that Claude's etching may have been commissioned by Cardinal Giulio Rospigliosi; *Claude Lorrain, 1600–1680* (New York: Brazillier, 1982), 407.

25 George Ferguson, *Signs and Symbols in Christian Art* (New York: Oxford University Press, 1959), 18.

THE BAROQUE PASTORAL
or the Art of Fragile Harmony

VÉRONIQUE SIGU

THE PASTORAL GENRE THAT TRIUMPHED in baroque theater and art claimed a long and noble genealogy. Though it was born in Ancient Greece with Theocritus's *Idylls* (3rd century B.C.E.), it is the Vergilian model of the pastoral (1st century B.C.E.) that most influenced writers and painters of the Renaissance and baroque periods. Vergil set his eclogues in Arcadia, which became the idealistic *locus amoenus* (pleasant place) where shepherds could poeticize freely, away from the vicissitudes of urban life; they could live in *otium* (at leisure), entirely devoted to poetic creation and musical expression. The Renaissance took on this literary model and developed it further; Italy in particular produced some major pastoral works that would have a tremendous impact on the formation of the baroque pastoral, and it introduced pastorals to the theatrical stage. Among the most influential pastorals are Jacopo Sannazzaro's *Arcadia* (1504), Torquato Tasso's *Aminta* (1573), and *Il Pastor Fido* (1590) by Battista Guarini.[1]

During the baroque age, the pastoral genre evolved in harmony with new literary and pictorial aesthetics. Focusing primarily on France between 1650 and 1700, this essay will explore the close links between two domains: pastoral theater and pastoral painting. I wish to show that theater and painting share the same aesthetic rules, according to which the internal dynamics of the work are based on the tension between the harmony of nature and the disruptive forces of dramatic conflict; and to discuss how pastoral landscape eluded the boundaries between illusion and reality, between the fictional fields of the shepherds and the very real gardens of Versailles.

From its classical beginnings, the pastoral genre was associated with the *stilus humilis* (simple style); its standard format is the eclogue, a short dialogue between two shepherds extolling the beauties of nature. Pastoral poets had neither the intention nor the means to compete with higher genres such as the tragedy or the epic.[2] Seventeenth-century theoreticians seem to have agreed on this point. Even Fontenelle and Boileau, two famous French critics and poets who were enemies on many grounds, shared the same view. As Fontenelle stated in the *Discours sur la nature de l'églogue*:

> Some realism is necessary to please the imagination: but the imagination is not hard to satisfy; it needs only a semi-realism. . . . The illusion and at the same time the attractiveness of the sheepfold consist consequently in offering to the eye only simplicity, from which we conceal the vileness.[3]

For Fontenelle, the defining principle of the baroque pastoral genre is not only its bucolic subject but also the attendant effect of simplicity and tranquility, an effect, it should be noted, that is visual in nature, "offer[ed] to the eye." Fontenelle's language echoes closely that of his rival critic Boileau, who urged a similar idealized simplicity:

> Such, lovely in its dress, but plain withal,
> Ought to appear a Perfect *Pastoral*:
> Its humble method nothing has of fierce,
> But hates the rattling of a lofty Verse.[4]

Boileau and Fontenelle's literary and dramatic precepts can be compared to the pictorial ones of the great art critic and theorist Roger de Piles, as enunciated in his *Cours de peinture par principes* (1709). In the chapter dedicated to landscapes, de Piles distinguished between two different styles, heroic and *champêtre* (rural), focusing primarily on the latter:

> The rural style is a representation of countries, rather abandoned to
> the caprice of nature than cultivated: We there see nature simple,
> without ornament, and without artifice; but with all those graces with
> which she adorns herself much more, when left to herself, than when
> constrained by art.[5]

There is no doubt that, for de Piles as for Fontenelle and Boileau, pastoral evocations must be plain, simple representations of a pliant, gentle nature. This simplicity, however, is not easy to achieve; as a result, pastoral settings are paradoxically complex.

Many baroque works of art, both literary and pictorial, portray an environment in essential but fragile harmony, with the threat of disruption never very far away.[6] This question of harmony is linked to the concept of *les bienséances* (decorum), which was central to the social life and thought of the seventeenth century. The pastoral had to give pleasure through a depiction of shepherd life that was simple and natural without being vulgar.

According to Fontenelle, the eclogue should represent an idealized shepherd.[7] Drawing another explicit parallel to pictorial representation, Fontenelle explained that pastoral poets must exercise judgment and "improve" their subjects if necessary: "The matter is not simply to paint; one has to paint objects that are pleasing to the sight."[8] From this perspective, Fontenelle criticized both Theocritus and a more immediate predecessor, Honoré d'Urfé, author of the early seventeenth-century pastoral *L'Astrée*. The shepherds in Theocritus's *Idylls* are much too close to real shepherds, while Céladon (a shepherd in *L'Astrée*) and his companions talk about life in such philosophical tones that verisimilitude is lost. The challenge in poetry was thus to find a delicate balance between refinement and rusticity, for an excess of one or the other was improbable or unpleasant.

The search for this simple harmony was also problematic for the pastoral landscape painter. In his codification of the genre, de Piles was less concerned with the physical features of shepherds than with their activities; he stressed the necessity of avoiding potentially static inaction, and maintaining the interest of beholders. In literary pastorals, the action is extremely reduced and revolves around love and poetical creation. In paintings, some features stemming from this convention are noticeable—

Figure 29
Artist Unknown, Italian,
Nymphs and Satyr, circa 1750
(Cat. No. 10)

shepherds playing lutes, pipes, or pan flutes, or nymphs frolicking with satyrs [FIG-
URE 29]—but the problem remains of exciting the viewer's interest in these conven-
tional pastoral diversions:

> I am persuaded that the best way to make figures valuable is, to make
> them so to agree with the character of the landskip [*sic*], that it may
> seem to have been made purely for the figures. I would not have them
> either insipid or indifferent, but to represent some little subject to
> awaken the spectator's attention, or else to give the picture a name of
> distinction among the curious.[10]

Clearly, it was a challenge for the pastoral landscape painter to represent a *locus
amoenus* as a setting for action; it had to be peaceful and yet somehow stimulating to
the beholder. Even when harmony is achieved, the threat of disruption is never far. In
pastoral theater, harmony can be disrupted by death, rapture, or loss of love; these
themes are also present in pictorial representations of pastoral landscapes.

Many baroque painters made use of the allegorical possibilities of pastoral land-
scape, most notably Claude Lorrain.[11] Claude's *Apollo Leading the Four Seasons in a
Dance* [FIGURE 28] demonstrates the tenuous equilibrium on which the pastoral
representation is built. Apparently, harmony reigns in the image; lush, peaceful sur-
roundings are the perfect stage for dancing, and goats graze placidly. Two elements,
however, threaten this blissful setting, serving as ominous reminders of the nature of
life and the inexorable march of time. First, a group of ruins in the background sym-
bolizes the ravages of the passing years: where a palace on top of the hill used to dom-

Figure 28

Figure 30
Artist Unknown
(after Francesco Albani),
*Actaeon Surprising Diana and Her
Nymphs*, 17th/18th century
(Cat. No. 12)

inate the landscape, there is nothing left but a few columns and walls invaded by vegetation and sheep. Second, the winged figure playing the lyre, slightly to the left of the carefree group, is not simply an angel but—as his beard and white hair indicate—a personification of Time, a clear reminder of mortality. Thus, what at first glance appears to be a perfectly gay and jolly dance is disturbed, though not undermined, by details closely associated with the *danse macabre* and the tradition of *vanitas* imagery (see Hunter, p. 52).

Sometimes the *locus amoenus* is the setting for a more detailed narrative, in which case the painter must select the moment of action that is appropriately tranquil, yet excitingly close to a moment of violent disturbance or disorder. Francesco Albani's representation of the story of Diana and Actaeon (seen here in a later copy [FIGURE 30][12]) derives from Ovid's *Metamorphoses* (III, lines 138–252), and depicts the moment when the goddess Diana is discovered in her wooded refuge by Actaeon, an overly curious young hunter. The harmony is disrupted here in two different ways: Diana's peaceful routine is interrupted by Actaeon; and Actaeon's fate consequently takes a dramatic turn, as Diana transforms him into a stag, to be pursued and killed by his own dogs. The painter chose to represent the precise moment of interruption (all the bathers turn to look at Actaeon) and transformation (the antlers on top of Actaeon's head are just noticeable); an earlier scene would have lacked incident, while a later one would have been too violent. The haven provided by the dark and secret woods and the clear and cooling spring represents the ideal escape from civilization, while the intruder reminds us of the fragility—even futility—of retreat.

Antoine-Achille Bourgeois de la Richardière's print after Horace Vernet's *Intrigue in the Groves of the Parc de Fontainebleau* [FIGURE 31] also touches upon this

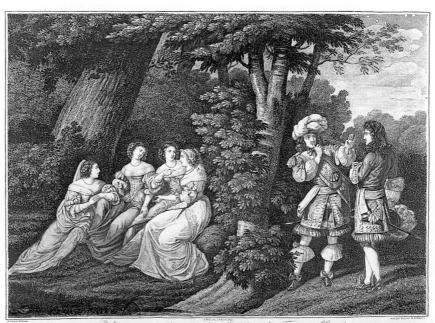

Figure 31
Antoine-Achille Bourgeois
de la Richardière (after Horace Vernet),
*Intrigue in the Groves of the Parc de
Fontainebleau*, early 19th century
(Cat. No. 15)

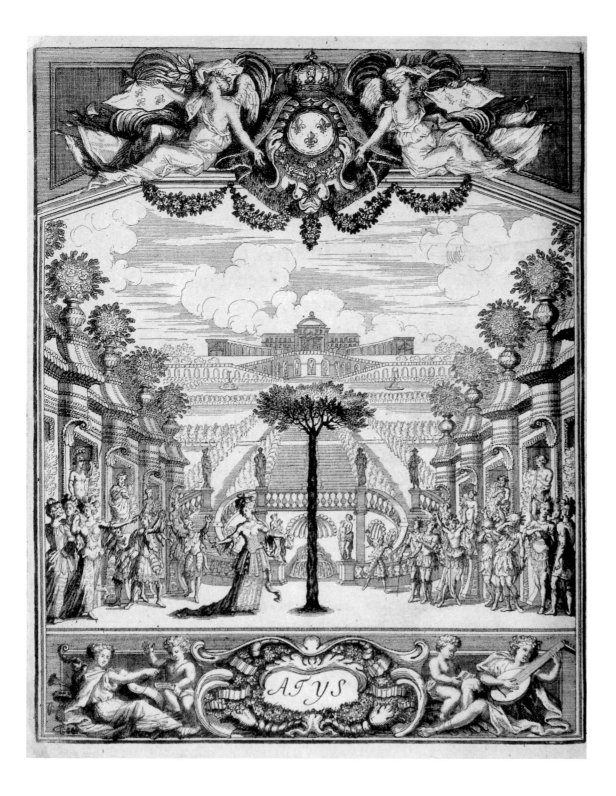

Figure 32
Philippe Quinault,
Frontispiece from *Atys; tragedie en musique*, 1699 (Cat. No. 14)

Figure 33
Francesco Montelatici,
called Cecco Bravo,
Angelica and Ruggiero,
circa 1640–1645 (Cat. No. 11)
See Color Plate 8

theme. The episode is taken from the journal of Mademoiselle de la Vallière, one of Louis XIV's mistresses; even though the engraving was made in the early nineteenth century, the subject and treatment are baroque in conception. The Sun King, struck by Mademoiselle de la Vallière's beauty, follows her into the gardens where she and a group of *demoiselles* have withdrawn. Persuaded that they are sheltered from the outside world by the woods, the ladies exchange intimate opinions about the court. Louis and his friend spy on them, and then retreat without revealing their presence. Once again the pastoral landscape seems to fail in its promise to provide a safe escape from the outside world: the vicissitudes of court life penetrate the most peaceful of groves.

This dialectic between harmony and disruption, which seems to underlie most baroque landscapes, provides the pastoral with its dramatic narrative force. But another tension, that between illusion and reality, makes the pastoral a uniquely theatrical form. While some literary genres of the seventeenth century, such as tragedy, relied heavily on the notion of verisimilitude and had to give the appearance of reality, pastoral aesthetics permitted obviously artificial devices on stage. For example, pastorals often include the intervention of a deus ex machina (literally, god from a machine). French baroque opera, which derived from the lyric pastoral of Pierre Perrin and its offspring the lyric tragedy, frequently featured magic, druids, and pagan deities on the stage.[13] In *Atys*, a lyric tragedy by Philippe Quinault, several key moments in the action rely on supernatural interventions. In one instance, the goddess Cybele, jealous of Atys's love for a mortal woman, nearly drives him to suicide; in the end, she takes pity and changes him into a pine tree [FIGURE 32].

Many pastoral dramas and paintings depict magic, gods, and monsters, in a variety of contexts. As seen above, classical mythology was a favorite source; a more

recent inspiration was Ludovico Ariosto's *Orlando Furioso* (1552), a chivalric romance set in Charlemagne's time. Cecco Bravo's painting *Angelica and Ruggiero* [FIGURE 33/COLOR PLATE 8] depicts an episode from cantos X and XI: Angelica, princess of Cathay, is saved by the paladin Ruggiero from the monstrous Orca. Ruggiero leaves his winged steed (shown flying away in the background) and hastens toward the princess to claim his reward of a thousand kisses. Cecco Bravo depicted the moment just before Angelica, by means of a magic ring, disappears into thin air, leaving Ruggiero behind.[14]

The supernatural charms of Ariosto's world later provided a rich resource for theatrical spectacles, and I will return to one such example at Versailles momentarily. But the magical elements are only one of the most obvious ways pastorals play with the notion of illusion. In Theocritus's *Idylls* and Vergil's *Eclogues*, gods very often appear disguised as shepherds, but beginning in the Renaissance and intensifying during the baroque period, aristocrats appropriated this disguise. Indeed, the mask was of particular importance in the baroque period; in a society where the social gaze imposed a powerful pressure on the public persona, masks represented escape from scrutiny and a way of presenting oneself in a carefully constructed, highly artful guise (see Norman, p. 7, and Ellenbogen, pp. 27–28). Very often aristocrats would play the role of shepherds, retiring to their *locus amoenus* and allowing themselves to compose poems and play music. The best-known historical example of this trend, even though it occurs at the end of the eighteenth century, is Queen Marie-Antoinette and her hamlet at Versailles.[15] It is not surprising to see the arts of portrait and pastoral painting merge, as is the case in Anthony Van Dyck's portrait of Lord Wharton [FIGURE 4]. Van Dyck portrayed Wharton as an elegant shepherd, with cape and crook, in front of a landscape. While a very subtle palette of tones seems to place the figure in perfect harmony with the background, a drape, hanging quite strangely from the top of the painting, separates the foreground and background, suggesting that the subject is only playing a role.

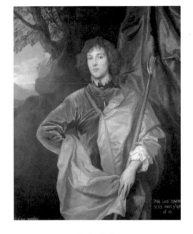

Figure 4

An even more complex means of revealing and deepening the illusion of representation is found in the widespread baroque strategy of constructing a *mise en abyme*, or a mirror effect. In the visual arts, this generally took the form of an image-within-an-image; courtly spectacles often featured a play-within-a-play. Because pastoral references figured so prominently in courtly role-playing and self-fashioning, pastoral productions intensified this kind of self-reflexivity, contructing often disorienting relationships between reality and performance. Molière's *Princesse d'Elide*, a *comédie-ballet* created in 1663, is exemplary here in its intricate game of illusions. The play was part of the *Plaisirs de l'isle enchantée*, a three-day celebration that inaugurated the new palace of Versailles and was set in its sumptuous gardens designed by André Le Nôtre. The theme of the spectacle was adapted from the ever-popular *Orlando Furioso*. Louis XIV himself appeared in the part of chevalier Roger and leading courtiers took on other roles. In one episode (in which Molière played Lycidias), Roger and the knights, held prisoners on an enchanted island, are allowed to present a play to pass the time—this play-within-a-play is *La Princesse d'Elide*. It is hard to know if the audience at Versailles identified Louis as the king or as Roger, and whether they interpreted the performance as a production directed at Roger's fictional retinue or as a modern entertainment created for the French court.[16]

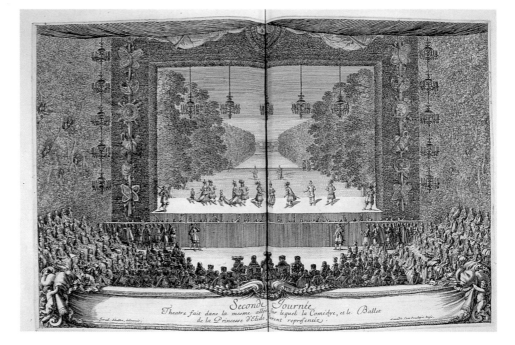

Figure 34
Israël Silvestre the Younger
(engraver), *Seconde journée,*
from *Les Plaisirs de
l'isle enchantée,* 1673
(Cat. No. 13)

Furthermore, the play within the play being watched by Roger/Louis XIV complicates the illusion further by presenting numerous pastoral interludes. In a dizzying triumph of theatrical showmanship, the pastoral scenes on stage mirrored perfectly the garden setting of the audience. And just as Molière's interludes featuring satyrs, singing echoes, and bucolic dances play ironically with the artificiality of pastoral conventions, so too Le Nôtre's formal gardens self-consciously mixed mythological statuary and heroic grandeur with the simple charms of nature. Thus the fictional stage world echoed the audience space in both pastoral simplicity and elaborate artifice. The engravings created to record the event perfectly illustrate this merging of stage illusion and audience reality inside a single idealized garden world [FIGURE 34]. It is a breathtaking reconciliation of the tension between nature and artifice, but one entirely typical of an age that considered the enjoyment of pastoral simplicity an occasion for spectacular theatrical invention.

1 For a more complete description of classical and Renaissance pastorals, see Luba Freedman, *The Classical Pastoral in the Visual Arts* (New York: Lang, 1989); Robert Cafritz, Lawrence Gowing, and David Rosand, *Places of Delight: The Pastoral Landscape* (New York: Crown Publishers, 1988); and Paul Alpers, *What is Pastoral?* (Chicago: University of Chicago Press, 1996). Jean-Pierre Van Eslande provides an excellent study of pastoral aesthetics in *L'Imaginaire pastoral du XVIIe siècle: 1600–1650* (Paris: PUF, 1999).

2 Servius's interpretation of Vergil is the first stylistic discussion of the pastoral genre; *Vergilii Bucolica et Georgica Commentarii,* ed. Georgius Thilo (Leipzig, 1887).

3 Bernard le Bovier de Fontenelle, *Poésies pastorales avec un traité sur la nature de l'églogue et une digression sur les Anciens et les Modernes* (Paris: M. Guéraut, 1688), in–12 (unless otherwise noted, all translations are by the author).

4 Nicolas Boileau-Despreaux, *L'Art poétique* (1674); *The Art of Poetry,* trans. unknown (London: R. Bentley and S. Magnes , 1683), canto II, 5–8.

5 Roger de Piles, *Cours de peinture par principes* (1709); *The Principles of Painting,* trans. Sir William Soames, rev. trans. John Dryden (London: J. Osborn, 1743), 124.

6 For an excellent analysis of this tension and enlightening examples, see Erwin Panofsky, "What is Baroque?" in *Three Essays on Style*

(Cambridge, Mass.: MIT Press, 1994), 17–88. For a broader discussion of the baroque, see John Rupert Martin, *Baroque* (New York: Harper & Row, 1977).

7 Fontenelle provides a very clear account of his idealized shepherd: "I acknowledge that pastoral poetry is devoid of charm if it is as vulgar as the natural, or if it relies only and precisely on things of the country. . . . What pleases is the idea of tranquility attached to the life of those who take care of sheep and goats" (386).

8 Fontenelle, 395.

9 For a complete description of these conventions, see Freedman.

10 De Piles, 140.

11 For a detailed explanation of the allegorical possibilities of landscape painting, consult Jonathan Unglaub, "The *Concert Champêtre*: The Crises of History and the Limits of Pastoral," *Arion, A Journal of Humanities and the Classics*, 3rd series, 5 (1997): 46–47.

12 Albani's original work is found in the Louvre and dates to ca. 1620–22. The Smart Museum's picture, which meticulously follows Albani's original, has long been considered a contemporary copy, though its style suggests a somewhat later, even eighteenth-century date. For the work's traditional dating, see F. R. Shapley, *Paintings from the Samuel H. Kress Collection, Italian Schools, XVI–XVIII Century* (New York: Phaidon Press, 1973), 77.

13 For a precise account of the debt that French opera owes to pastorals, see Catherine Kintzler, *Poétique de l'opéra français de Corneille à Rousseau* (Paris: Minerve, 1991).

14 Timothy J. Standring, catalogue entry in *The David and Alfred Smart Museum of Art: A Guide to the Collection*, ed. Sue Taylor and Richard A. Born (New York: Hudson Hills Press, 1990), 50; and Allie Terry, catalogue entry in *The Place of the Antique*, ed. I. D. Rowland (Chicago: The David and Alfred Smart Museum of Art, 1999), 26.

15 On the social role of masks, see Norbert Elias, *The Civilizing Process*, trans. Edmund Jephcott (Cambridge, Mass., and Oxford: Blackwell, 1994).

16 For a detailed history of the spectacles at the court of Versailles, see Philippe Beaussant, *Les Plaisirs de Versailles* (Paris: Fayard, 1996).

 Exhibition Checklist

1 Jacques Callot
French, 1592–1635
Entry of Monseigneur Henry de Lorraine,
pl. 7 from *The Combat at the Barrier,* 1627
Engraving and etching
8 3/8 x 12 3/16 in. (21.2 x 31 cm)
2000.16g
Figure 2

2 Jacques Callot
French, 1592–1635
Entry of His Highness as the Sun, pl. 8
from *The Combat at the Barrier,* 1627
Engraving and etching
8 3/8 x 12 3/16 in. (21.2 x 31 cm)
2000.16h
Reverse Cover

3 Jacques Callot
French, 1592–1635
Entry of His Highness on Foot, pl. 9 from
The Combat at the Barrier, 1627
Engraving and etching
8 3/8 x 12 3/16 in. (21.2 x 31 cm)
2000.16i
Figure 3

4 Jacques Callot
French, 1592–1635
Combat at the Barrier, pl. 10 from
The Combat at the Barrier, 1627
Engraving and etching
8 3/8 x 12 3/16 in. (21.2 x 31 cm)
2000.16j
Figure 23

5 Franz Anton Maulbertsch
Austrian, 1724–1796
The Pancake Woman, circa 1785–1790
Oil on wood panel
12 1/16 x 14 1/16 in. (30.7 x 35.8 cm)
Purchase, Gift of Viola Manderfeld,
1978.185
Figure 15

6 Franz Anton Maulbertsch
Austrian, 1724–1796
The Sausage Woman, circa 1785–1790
Oil on wood panel

12 1/16 x 14 1/16 in. (30.7 x 35.8 cm)
Purchase, Gift of Viola Manderfeld,
1978.184
Figure 16/Color Plate 4

7 Gabriel-Jacques de Saint-Aubin
French, 1724–1780
*Gabriel de Saint-Aubin Executing the
Portrait of the Bishop of Chartres,* 1768
Pen and black ink, and brush and gray
wash, with graphite, on ivory laid paper
9 3/16 x 7 1/4 in. (23.3 x 18.4 cm)
The Art Institute of Chicago, Worcester
Sketch Fund, and gifts of Mr. and Mrs.
Robert Meers, Mr. and Mrs. Roy
Friedman, Mrs. Charles Folds, and Mrs.
George B. Young, 1981.152
Figure 12

8 Jacques Callot
French, 1592–1635
*A Man Playing a Lute while a Woman
Dances,* pl. 34 from *Capricci di Varie
Figure,* 1617
Etching
2 5/16 x 3 1/4 in. (5.8 x 8.3 cm)
University Transfer from Max Epstein
Archive, 1967.116.79
Figure 14

9 Attributed to Issac Van Ostade
Dutch, 1621–1649
Peasants Drinking from a Cask, 1647
Pen and brush and ink with wash and
charcoal on ivory wove paper
5 9/16 x 7 5/8 in. (14 x 19.4 cm)
Bequest of Joseph Halle Schaffner in mem-
ory of his beloved mother, Sara H.
Schaffner, 1973.142
Figure 13

10 Artist Unknown
Italian
Nymphs and Satyr, circa 1750
Pen and bistre on ivory laid paper
5 3/8 x 6 3/8 in. (13.6 x 16.2 cm)
Gift of Mrs. Eugene Davidson, 1974.54
Figure 29

11 Francesco Montelatici, called Cecco Bravo
Italian, Florentine School, 1607–1661
Angelica and Ruggiero, circa 1640–1645
Oil on canvas
12 ¾ x 17 ½ in. (32.4 x 44.5 cm)
Gift of the Samuel H. Kress Foundation,
1973.42
Figure 33/Color Plate 8

12 Artist Unknown (after Francesco Albani,
Italian, 1578–1660)
*Actaeon Surprising Diana and Her
Nymphs*, 17th/18th century
Oil on canvas
21 x 25 ⅛ in. (53.3 x 63.8 cm)
Gift of the Samuel H. Kress Foundation,
1973.43
Figure 30

13 Author Unknown
French
 Israël Silvestre the Younger (engraver)
 French, 1621–1691
Les Plaisirs de l'isle enchantée
(Paris, 1673 [1674])
Printed book
16 ⅛ x 10 ³⁄₁₆ in. (41 x 27.5 cm)
The Newberry Library, Chicago
Figure 34

14 Philippe Quinault
French, 1635–1688
Atys; tragedie en musique (Paris, 1699)
Printed book
8 x 6 ⅜ in. (20.5 x 16.5 cm)
Department of Special Collections,
the University of Chicago Library
Figure 32

15 Antoine-Achille Bourgeois de la
Richardière (after Horace Vernet,
French, 1789–1863)
French, active early 19th century
*Intrigue in the Groves of the Parc de
Fontainebleau*, early 19th century
Color engraving and stipple engraving
13 ¼ x 17 ⅜ in. (36.6 x 44.2 cm)
University Transfer from Max Epstein
Archive, Gift of Mrs. C. Phillip Miller,
1963, 1967.116.160b
Figure 31

16 Anthony Van Dyck
Flemish, active in Italy and England,
1599–1641
Philip, Lord Wharton, 1632
Oil on canvas

52 ½ x 41 ⅞ in. (133.4 x 106.4 cm)
National Gallery of Art, Washington,
Andrew W. Mellon Collection, 1937.1.50
Figure 4

17 French, Chantilly Factory
Shell-form Bowl with Platter, circa 1750
Glazed soft-paste porcelain
Bowl, height 4 ½ in. (11.4 cm),
length 10 ½ in. (26.7 cm);
platter, length 13 ½ in. (34.3 cm)
Gift of Mrs. Helen Regenstein, 1976.10
Color Plate 5

18 Laurent de La Hyre
French, 1605–1656
Panthea, Cyrus, and Araspus, 1631–1634
Oil on canvas
56 ¾ x 41 in. (114 x 104.2 cm)
The Art Institute of Chicago, Major
Acquisitions Centennial Endowment,
1976.292
Figure 5

19 Noël Hallé
French, 1711–1781
Joseph Accused by Potiphar's Wife,
circa 1740–1744
Oil on canvas
55 ¾ x 65 ⅝ in. (141.6 x 166.7 cm)
Purchase, Gift of The Mark Morton
Memorial Fund and Mr. and Mrs. Eugene
Davidson, 1974.116
Figure 1/Color Plate 1

20 Pierre Daret de Cazeneuve (after Jacques
Stella, French, 1632–1677)
French, 1604–1678
*Faith Combatting Heresy with the Divine
Light of the Holy Spirit*, title page to
*Conciliorum omnium generalium et
provincialium, collectio regia*, 1644
Engraving
19 ⅜ x 13 ⅝ in. (49.1 x 34.6 cm)
Gift of Mrs. Eugene Davidson, 1974.55a
Figure 17

21 Pietro Aquila (after Carlo Maratta,
Italian, 1625–1713)
Italian, 1650–1692
The Blessed Virgin in Glory, 1671
Etching
26 ¾ x 17 ¾ in. (69 x 45.1 cm)
University Transfer from Max Epstein
Archive, 1967.116.164
Figure 21

22 Artist Unknown
(formerly Gérard de Lairesse)
French or German (?)
The Sacrifice of Polyxena
(formerly *The Sacrifice of Iphigenia*),
late 17th or 18th century
Oil on canvas
56 x 38 ½ in. (142.2 x 97.8 cm)
Gift of Max Schwartz, 1961, 1967.12
Figure 19

23 Francesco Fontebasso
Italian, Venetian School, 1709–1769
The Martyrdom of Saint Catherine, 1744
Oil on canvas
16 ¹⁵⁄₁₆ x 24 ⅜ in. (42.9 x 61.9 cm)
Purchase, The Cochrane-Woods
Collection, 1978.23
Figure 18/Color Plate 6

24 Francesco Bertos
Italian, active in Rome and Venice,
1693–1739
Marcus Curtius, circa 1690–1710
Cast bronze
29 ⅛ x 19 ⅛ x 18 ⅛ in.
(74 x 48.6 x 46 cm)
Lent Anonymously, 19.1997
Figure 22

25 Carlo Innocenzo Carlone
Italian, 1686–1775
Study for *Parnassus Triumphant*,
circa 1720–1730
Oil on canvas
19 ½ x 35 in. (49.5 x 88.9 cm)
Private Collection, Chicago
Figure 11/Color Plate 3

26 Adriano Manglard (after Ciro Ferri,
Italian, 1634[?]–1689)
French, active in Italy, 1695–1760
*Design for the Cupola of Sant'Agnese,
Rome,* mid-18th century
Engraving
9 ½ x 25 ¼ in. (24.1 x 64.1 cm)
University Transfer from Max Epstein
Archive, 1967.116.178
Figure 7

27 Daniel Gran
Austrian, 1694–1757
Design for a Ceiling, circa 1720–1757
Pen and black and brown inks with brown
and sepia washes and preliminary graphite
underdrawing on laid paper
14 x 16 ½ in. (35.6 x 41.9 cm)
Gift of Mr. and Mrs. Frank H. Woods, Jr.,
1980.28
Figure 9/Color Plate 2

28 Bernard le Bovier de Fontenelle
French, 1657–1757
 I. D'Olivar (engraver of pl. 1 [figure 10])
 Spanish, active in Paris,
 late 17th century (?)
Entretiens sur la pluralité des mondes
(3rd ed., Amsterdam, 1701)
Printed book
5 ⅙ x 3 ¼ in. (13 x 8 cm)
Department of Special Collections,
the University of Chicago Library
Figures 6 and 10

29 Jean-Puget de La Serre
French, 1600–1665
The Mirrour which Flatters Not
(London, 1639)
Printed book
5 ⅙ x 3 ½ in. (13 x 8.5 cm)
Department of Special Collections,
the University of Chicago Library
Figure 25

30 Claude Gellée, called Le Lorrain
French, 1600–1682
*Apollo Leading the Four Seasons in a
Dance,* 1662
Etching and engraving
7 ⅞ x 10 ½ in. (20 x 26.7 cm)
Gift of Mr. and Mrs. William Salloch,
1987.48
Figure 28

31 Artist Unknown
French
*Allegory of Truth, Honor, Prudence, Vice,
and Posterity,* circa 1745–1775
Cast bronze
28 x 12 x 11 ½ in.
(71.1 x 30.5 x 29.2 cm)
Lent Anonymously, 18.1997
Figure 27/Color Plate 7